IMAGES
of America

GREEKS OF STARK COUNTY

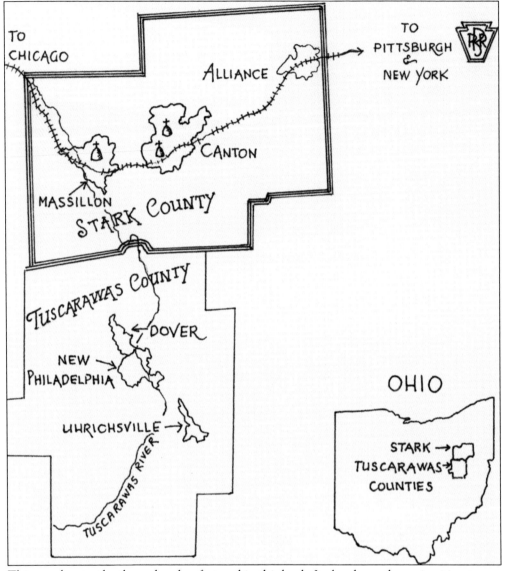

This map locates the three churches featured in this book. It also shows the main cities, towns, and transportation routes. In the early 19th century, the Ohio and Erie Canal that ran along the Tuscarawas River was an important route through Stark County. It would be replaced by the Pennsylvania Railroad. Trolley cars also would follow the old canal route, connecting Massillon to Tuscarawas County. (Map by Chris Gonzales.)

On the cover: Many Greeks were involved in the confectionery business, but none was as successful as Peter George. He operated the Sugar Bowl in downtown Massillon, later opening another store in Massillon and the Palace Sugar Bowl in Canton. George and his wife Marian (second row, middle) were assisted by longtime employees Bertha (first row, second woman from the left) and Tom Varas (first row, right). (Courtesy Rudy Turkal and Tom Persell.)

IMAGES
of America

GREEKS OF STARK COUNTY

William H. Samonides and
Regine Johnson Samonides

ARCADIA
PUBLISHING

Published by Arcadia Publishing
Charleston, South Carolina

Printed in the United States of America

Library of Congress Control Number: 2008940655

For all general information contact Arcadia Publishing at:
Telephone 843-853-2070
Fax 843-853-0044
E-mail sales@arcadiapublishing.com
For customer service and orders:
Toll-Free 1-888-313-2665

Visit us on the Internet at www.arcadiapublishing.com

In memory of those who have gone before

CONTENTS

Acknowledgments 6

Introduction 7

1. St. Haralambos Greek Orthodox Church 9

2. Holy Trinity Greek Orthodox Church 39

3. St. George Greek Orthodox Church 69

4. The American Hellenic Educational
 and Progressive Association 99

Epilogue 127

ACKNOWLEDGMENTS

This book would not have been possible without the support of the Greek Orthodox Churches of Holy Trinity, St. George, and St. Haralambos; the Greek Orthodox Alliance of Stark County; the American Hellenic Educational and Progressive Association Canton Chapter 59; and the Daughters of Penelope Chloris Chapter 40. We thank Rev. Dr. Nicholas Gamvas, Rev. Dr. Daniel Rogich, and Rev. Fr. Constantine Valantasis. We are also grateful to Joseph and Albis Samonides, Joanna and James Palacas, and Sophie Pergins.

Over 150 people submitted prized photographs for this volume. Whether the photographs were ultimately included or not, we appreciate the leap of faith. For their help, we thank Angie Anastas, Michael Anastas, Sam Anastas, Flora and John Anderson, Andrew J. Andreadis, James Chiamardas, Rebecca Decker, Sophia Effantis, John Ermidis, Evelyn Eustathios, Beth Gatsios, George Georgeson, Phil Giavasis Sr., Joanne Goumas, Peggy Hadjian, Olympia Kalagidis, Sophia Klide, Helen Kostel, George Lazarides, Marie Lekorenos, Mary and Joseph Manolas, Bertha Marshall, George Michalos, Paul Pappas, Bessie Samuels, Elizabeth Schrock, Steve Stamoules, Mary Steve, Alexandra Tank, Elizabeth and Lazer Tarzan, Mary Trifelos, Angelina Verginis, and Irene Vianos. We have also used an anecdote from Athanasia Papademetriou's *Presbytera: The Life, Mission, and Service of the Priest's Wife.*

Our editor, Melissa Basilone, smoothed the way. Rudy Turkal was very generous, as was Fred Miller of the Tuscarawas County Historical Society. Rev. Fr. Alex Karloutsos of the Greek Orthodox Archdiocese of America and Abhishek Joshi were especially helpful. Our work benefited by assistance from clerk of courts Phil G. Giavasis and his staff, the Stark County District Library Genealogical Division, the Stark County Probate Court, the William McKinley Presidential Library and Museum, and Alexandra Nicholis of the Massillon Museum. The archives of the Ohio Historical Society in Columbus, the University of Minnesota Immigration History Research Center, the Newberry Library and the Hellenic Museum and Cultural Center in Chicago, the Family History Library in Salt Lake City, and the Allen County Public Library in Fort Wayne, Indiana, also provided research havens.

Finally, we lovingly acknowledge Morphe Xenos, Pete Samonides, Milt Manos, George Sideropoulos, and Betty and Merle Hansen. May their memory be eternal.

INTRODUCTION

Greeks came to Stark County from Greece, the islands, and Asia Minor, especially the Pontos region along the Black Sea. Some came to make money, some to establish a new home, and some to find refuge. For all of them, Stark County was an unlikely destination. Greeks who had lived in a moderate climate close to the sea found the winters in northeastern Ohio cold and long. Stark County is situated in a rich agricultural region, and most Greek immigrants came from rural areas, but the available work was in the cities, where many became factory workers.

In the early 20th century, Ohio was the manufacturing heart of the nation, and Stark County was the fastest-growing area in the state. It was a leading producer of paving brick, enamelware, tinplate, alloy steel, and vacuum cleaners. Most Greeks arrived by 1921, with immigration peaking just before and after World War I. This coincided with the explosive growth of the steel industry. The demand for labor in the steel mills and subsidiary industries could not be met by the local or even the regional population, so industrialists welcomed the immigrants.

Greeks came to the United States by ship and to Stark County by train. The Pennsylvania Railroad was the main passenger line between New York and Chicago, the North American cities with the largest Greek populations. Passengers crossing Stark County saw miles of steel mills lining the tracks from the county line in Alliance to the Tuscarawas River in Massillon. It was a panorama of prosperity, and the area would soon have one of the largest Greek populations in America. This book focuses on how that community took shape.

It was not always easy for Greeks, who love a good argument, to find common ground. Those from the Peloponnese peninsula of Greece had enjoyed independence from the Ottoman Turks since 1830. Many of the immigrants from this area established themselves in business and became American citizens early. Those who came from Asia Minor had been shaped by a different historical experience. They remained under Ottoman authority for another century. As Christians unwilling to convert to Islam, they had been subjected to ethnic cleansing. Their fate was decided on the battlefield. The defeat of the Greek army at Smyrna in September 1922 was accompanied by brutal suppression. Those who survived were forced to leave their homes forever in a massive international population exchange. With the establishment of the new nation of Turkey, these Christians lost everything and were scattered throughout the world. Greece accepted some refugees but not all. They came in great numbers to Stark County, where the Pontian community remains one of the largest in the United States. For the Greeks from Greece and those from Asia Minor, some of whom did not even speak the same language, it was the Greek Orthodox religion that formed a bond.

Three parishes of the Greek Orthodox Church formed in Stark County. The earliest developed in Canton, the largest city and county seat. St. Haralambos Greek Orthodox Church was established in 1913, but the community remained unified for only four years. Royalist parishioners supported King Constantine, the brother-in-law of the German kaiser, who advocated that Greece remain neutral in World War I. Others supported Prime Minister Eleftherios Venizelos,

who urged that Greece join in the fight against Germany and its Ottoman Turkish allies. The Venizelist parishioners split off from St. Haralambos to establish Holy Trinity Greek Orthodox Church in 1917, with the two Canton parishes embodying these Old World political divisions. The third parish, St. George Greek Orthodox Church, was established in Massillon in 1931. During the Depression, internal dissension was not an option; survival required a community that was unified. As the parish worked together, it became imbued with the civic pride and independent spirit that characterize the city of Massillon.

The Canton parishes were neighborhood churches, but their neighborhoods were very different. St. Haralambos was located downtown where the first Greek immigrants settled and were employed as waiters, dishwashers, and bootblacks until they could find better-paying jobs or establish businesses of their own. By contrast, Holy Trinity was built in a neighborhood on the edge of the city that had been carved out of a farm and subdivided to accommodate workers for the expanding steel mills and factories. St. George was located in downtown Massillon and was a regional parish drawing parishioners from Massillon and surrounding counties.

Both St. Haralambos and Holy Trinity were established before the Greek Orthodox Archdiocese of America was formed in 1922. In the early years, competing hierarchs, attempting to extend their authority, visited populous Stark County often. The elevation of Archbishop Athenagoras in 1931 established unity in the archdiocese. The Depression also damped political fires. Throughout the country, parishes that had split apart over politics reunited under financial pressure. Holy Trinity, however, resisted. The parish was solvent, and the emotional wounds were still painful. Asia Minor immigrants, who had been persecuted for their religion and whose family members had been killed by Turks, were themselves dismissed as "Turks" by their fellow Greeks, an offense that stings their descendants to this day. This unhealed breach has caused pain, but it has also stimulated competition and growth.

No matter where they came from, the pioneer immigrants had challenges to overcome at every step. Although industrialists were content to benefit from Greek labor, the union movement that would improve workplace safety was still developing. Many laborers were killed or maimed at work. Respiratory diseases, often contracted because of poor working conditions, were common and deadly. Outside the workplace, many mothers did not survive childbirth, and infant mortality took a heavy toll.

Everyone depended on the help of family and friends. Most Greeks had come to Stark County because someone from home had found work and encouraged others to follow. Once here, they established complex networks of interrelatedness. Those who agreed to be *koumbari*, to sponsor a baby's baptism or a couple's wedding, became part of the extended family. They helped in coping with an environment that was sometimes hostile to immigrants. The pressures of World War I had brought an increase in xenophobic nationalism. Also, the flood of immigrants and the families they raised strained housing capacity and the schools.

Organizations like the American Hellenic Educational and Progressive Association educated Greeks on how to assimilate into American society and defended them against discrimination. The Greek communities helped their people survive two world wars and the most severe, extended economic downturn in modern history. Somehow, despite the struggle, people earned enough to raise families and support their churches.

What follows are photographs and stories of some of the Greek immigrants who came and settled in this corner of northeastern Ohio during the first half of the 20th century. Their great adventure shaped their lives. The sacrifices they made created a vastly different future for their children. Their stories deserve to be told and savored. As Jane Austen urges in *Pride and Prejudice*, "Think only of the past as its remembrance gives you pleasure."

One

St. Haralambos Greek Orthodox Church

In the early years of the Greek community in Canton, immigrants settled downtown near the train station where there was a concentration of jobs and inexpensive housing. Priests from Pittsburgh came to officiate at funerals, weddings, and baptisms. There was talk of establishing a church, but during the Balkan Wars of 1912 and 1913, many men returned to Greece to fight the Ottoman enemy. In the summer of 1913, there was a surge of immigrants from Asia Minor. Along with the returning soldiers, they provided a critical mass. In the autumn, the parish of St. Haralambos Greek Orthodox Church was established. The oldest and largest parish, it is the Greek Orthodox mother church of Stark County.

The first priest, Fr. Leonidas Athamakos, was a pioneer of Greek Orthodoxy in America. He held services in a rented space downtown. The parish purchased property in February 1915, and the State of Ohio issued the parish charter in May. It would take more than two years for construction of the church to begin. As the parish was making plans, it was torn apart by the political storm raging in Greece and in Greek communities worldwide. A core of the parish was from the staunchly royalist village of Stemnitsa. Backers of Prime Minister Eleftherios Venizelos split off to form the new parish of Holy Trinity Greek Orthodox Church.

St. Haralambos, however, was advantageously located in the downtown business district and had many prosperous parishioners. Plans proceeded, and the parish chose to build an impressive church. During the Depression, the parish almost defaulted on the mortgage, but the community rallied to save the church.

Following World War II, the deterioration of the neighborhood and the move to the suburbs by many parishioners led the parish to consider rebuilding elsewhere. Instead, the parish took the remarkable step of moving the church building to a new site. In June 1958, multitudes watched the slow procession of the two halves of the church through the streets. The sturdy construction that had been so expensive made it possible to perform this engineering feat. Fifty years later, St. Haralambos continues to flourish in its new location.

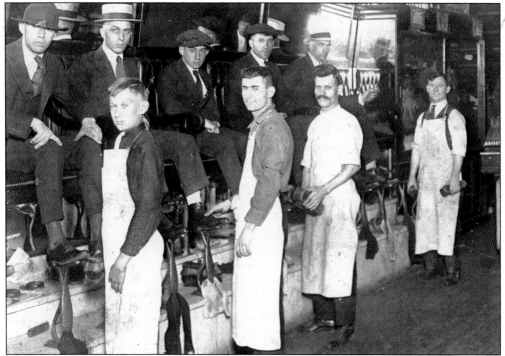

Booming industry attracted thousands of Greeks to Stark County. Some immigrants worked as bootblacks before obtaining a higher-paying factory job. The shoe shine parlor was among the earliest Greek-owned businesses. It was labor intensive and did not require much capital. This shop at 110 Cleveland Avenue NW was run by Peter Papadopoulos and Harry Karalis, the best man at Papadopoulos's wedding at St. Haralambos Greek Orthodox Church in 1925. (Courtesy Peter Papadopoulos.)

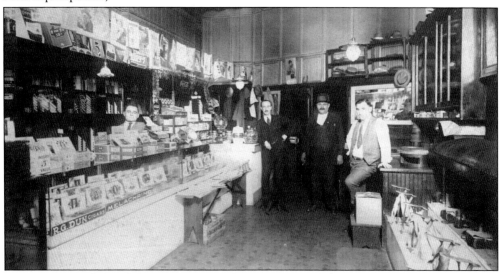

George Mannos (behind the counter) arrived in 1910 with only $28. Within four days, he secured a job in an automobile spring factory. Nine years later, he had saved enough to own this shop in the 500 block of Tuscarawas Street East, where a customer could buy cigars, have his hat cleaned and shoes shined, and play a game of billiards. (Courtesy Dr. John Mannos.)

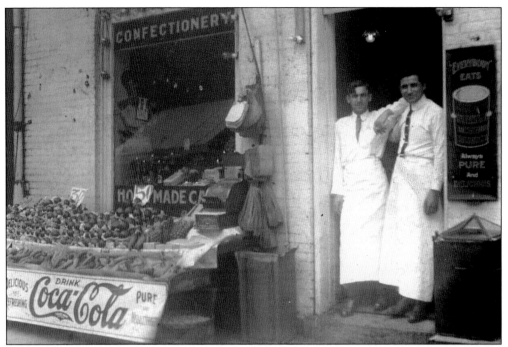

Early immigrants would often start by selling fruits and vegetables from pushcarts, then open a grocery. Some—like Harry, Jim, and George Trifelos—also became involved in the confectionery business. Harry (on the right) is shown at the shop on Market Avenue South in 1923, standing beside an employee. Although the confectionery featured homemade candy and ice cream, it also continued to sell produce. (Courtesy Mary Trifelos.)

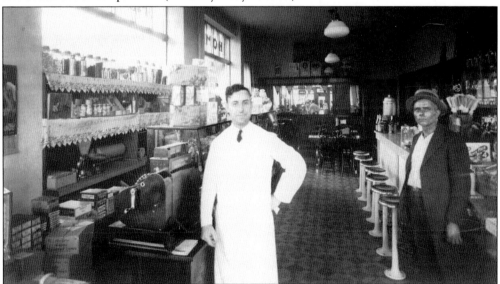

John and George Vianos (Vianatakis) arrived in the United States from Crete in 1912 and lived in western Pennsylvania before moving to Canton. Along with their brother Michael, who arrived in 1915, they operated confectioneries on the north, east, and south sides of the square downtown. John is standing beside the cash register and the pristine glass display cases, while a customer stands near the soda fountain. (Courtesy Irene Vianos.)

At first, the Greek population was mostly male, and there were few marriages. After Fr. Leonidas Athamakos arrived at St. Haralambos Greek Orthodox Church, one of the early weddings was in 1915, uniting Christina Economopoulou and Argyrios Zissiades, who later changed his name to Harry Thomas. He had left Romania as a barber. In Canton, he operated a bus line and later owned the Betsy Ross Restaurant downtown. (Courtesy Harry Thomas.)

Peter Tender arrived in the United States in 1903. After receiving his citizenship, he returned to Greece to marry. He operated a confectionery in Alliance, where many Greeks worked in railroad maintenance and at the steel mills. Tender and wife Christina's daughter Lula (on the left) is said to have been one of the first children baptized at St. Haralambos. The family later moved to Lorain. (Courtesy Olga Michalos.)

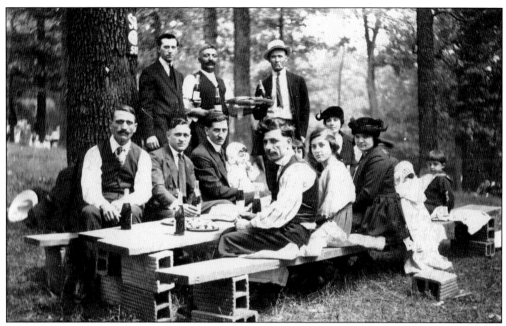

One of the most anticipated and painstakingly planned annual events was the church picnic. They were all-day affairs, where parishioners shared homemade specialties, danced, and played games. At this table, constructed of boards and cinder blocks, a well-dressed group is having something to eat and drink. Among those enjoying the occasion are the Ekonomou family (first row) and William Eustathios (second row, second from the left). (Courtesy Evelyn Eustathios.)

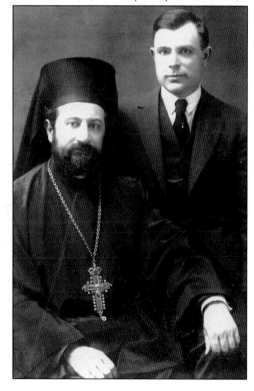

Fr. Chrysostomos Lavriotes came to the United States in 1916 and became the third priest at St. Haralambos. He is shown here with Peter Bossis, who was parish president in 1924. The priest's strong royalist political stance polarized parishioners. Within seven months of his arrival, dissension led to schism and the creation of Holy Trinity Greek Orthodox Church. Lavriotes would serve St. Haralambos for 16 years. (Courtesy Mary Manolas.)

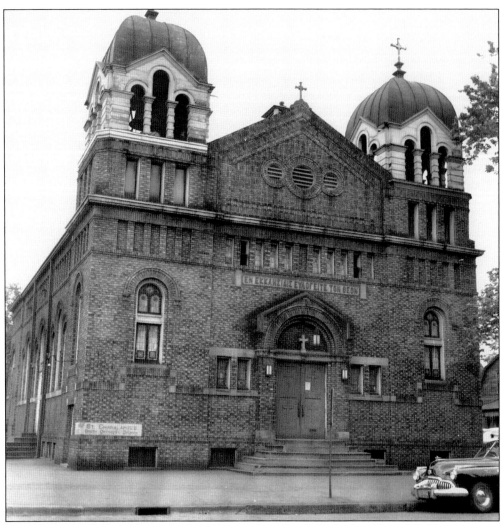

In 1913, the newly formed parish of St. Haralambos Greek Orthodox Church held services on the rented third floor of a building at the corner of Third Street and Walnut Avenue SE. There was an adjoining apartment for the priest. The first purchase of property for a new church was made in 1915. On September 30, 1917, in an elaborate ceremony witnessed by 3,000 people, Peter Tender and his wife were given the privilege of laying the cornerstone, because they had contributed the most to the building fund that day. In charge of the ceremony was Archbishop Germanos of Brooklyn, New York, acting head of the Syrian Orthodox Church in North America. Ecclesiastical authorities from Greece would not arrive in America until the following year. The dedication of the new church took place on February 29, 1920, with more than 10,000 in attendance. It was reported to be the largest Greek Orthodox church in Ohio. Although the original contract, exclusive of interior decorations, was under $40,000, construction would eventually cost $100,000. The large debt would not be easy to pay off. (Photograph by Joseph Manolas.)

Most of the early leaders of St. Haralambos Greek Orthodox Church were businessmen. Many, like the four Ergon (Economopoulos) brothers, operated confectioneries. Seated are Themistocles (left) and Harry; standing are John (left) and Antonios. John immigrated in 1907, ran a confectionery in Massillon, then moved to Canton. In 1915, he signed the St. Haralambos charter. He also served as parish president in 1918 and 1919, while the church was being built. (Courtesy Harry Thomas.)

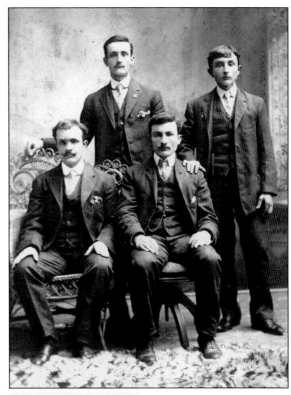

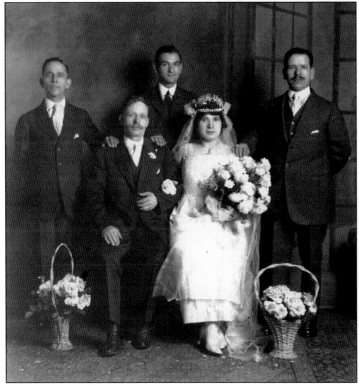

By 1912, the Foradas brothers were operating an important rooming house for Greek immigrants at 429 South Cherry Street near the train station. Others from their home village of Stemnitsa followed them to Canton, forming a nucleus of parishioners at St. Haralambos. In this 1920 wedding photograph of John and Froso Foradas, standing are, from left to right, George Foradas, best man George Antoney, and Michael Foradas. (Courtesy Harriet Marinos.)

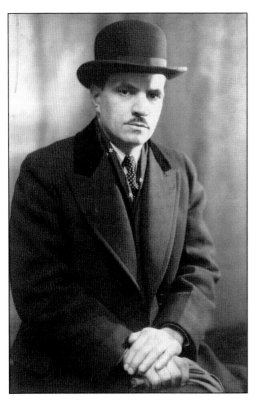

Dapper businessman William Petropoulos first came to the United States in 1902. By 1917, he had moved to Akron, where he worked in a confectionery. Later he started Canton Importing, a store that still operates today under different ownership. After the war, he sold the Canton store, opening another in Albuquerque, New Mexico. In 1959, he was brutally murdered at work. The case was never solved. (Courtesy John Anderson.)

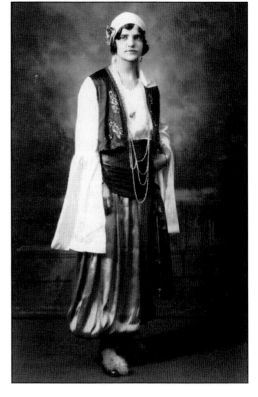

William Petropoulos's brother Louis was also living in Akron. He obtained his American citizenship and in 1921 returned to Greece to prepare their widowed mother, Kalliopi, and sisters Tasia, Toula, and Anna to emigrate. Anna, the youngest, had a dramatic flair and is shown here in native dress. The three sisters would marry and raise families in the St. Haralambos Greek Orthodox Church community. (Courtesy John Anderson.)

Toula Petropoulou and George Antoney (Antonopoulos) were married in 1926. Antoney had arrived in Pittsburgh in 1908, later opening a billiards parlor in Akron with John Anderson (Andritsanos). The inseparable duo married sisters and moved to Canton, sharing a duplex on Harrison Avenue NW. They were partners in the Malted Milk Shoppe at 131 Tuscarawas Street East. It boasted the first ice-cream machine in the city. (Courtesy John Anderson.)

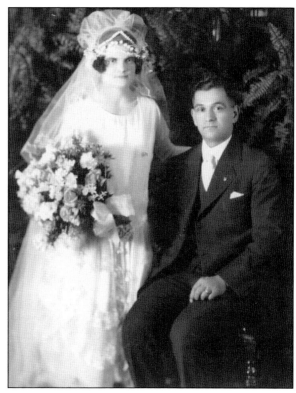

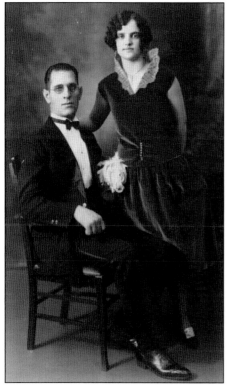

This is the engagement photograph of Anna Petropoulou and John Anderson. He arrived in the United States in 1910 as a teenager and started working in Pittsburgh for his brother-in-law Theodore Flocos to pay off his older sister's $500 dowry. Anderson's chores included cleaning spittoons in the billiards parlor. He fulfilled his obligation, became a citizen in 1918, and left for Ohio to make his fortune. (Courtesy John Anderson.)

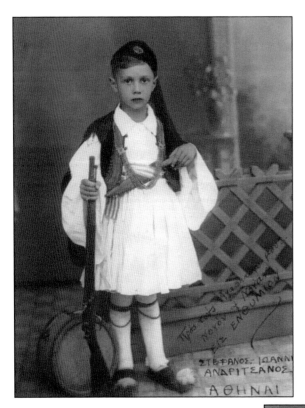

John and Anna Anderson's son John is posing in an evzone outfit during a trip to Greece in 1936. As a boy, he worked at the family confectionery wrapping candy. He was gradually given greater responsibility. From dishwasher, he moved to weighing and selling candy. Later he was a cashier and soda jerk. Eventually he graduated to making sandwiches with his uncle George Antoney. (Courtesy John Anderson.)

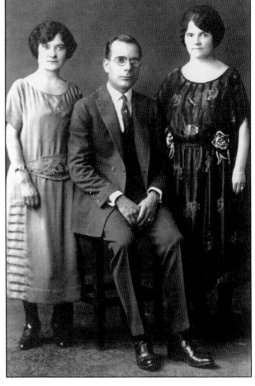

Tasia was the oldest Petropoulou daughter. She married Jack C. Biris in Akron and is shown (on the right) with her husband and sister-in-law Panagiotitsa. Biris was also from Stemnitsa, where he had studied at a school for jewelers. They moved to Canton, where he worked for George Dueble Jewelers. Later he opened Jack C. Biris Jewelers in the First Federal Savings and Loan building. (Courtesy Evelyn Eustathios.)

Two women soliciting donations for the church stopped at the home of William Eustathios, who lived across the street from St. Haralambos Greek Orthodox Church. When he offered them some cherry preserves he had made, they were so impressed that they introduced him to their friend Panagiotitsa Biris. The resulting marriage was held in Akron on April 21, 1923. For years, the Eustathios family had a special relationship with the church. Living across the street, they often handled issues that came up at times when the priest was not available. Panagiotitsa operated Mary's Grocery from their home. In 1943, William and his brother-in-law Harry Biris purchased one of the oldest confectioneries in Canton at 330 Market Avenue North (below) next to the Ohio Theater. In 1949, the shop was completely remodeled and renamed the Candy Bowl. (Courtesy Evelyn Eustathios.)

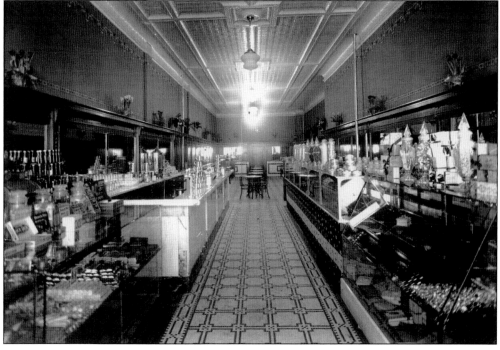

One of the founders of St. Haralambos Greek Orthodox Church was Harry Trifelos (Haralambos Triantaphillopoulos), the youngest of three brothers from Stemnitsa who came to Canton. In 1913, when suggested names for the new church were placed in a hat, St. Haralambos was drawn. Harry always felt a special connection with the church that shared his name. He is shown at the left as a young man before his army service in World War I. Seen below in 1929, he married Helen Johnson (Eleni Ioannou) in Lynn, Massachusetts. Their best man (standing) was Canton restaurateur Frank Mergus. Trifelos was quite a catch: a veteran, American citizen, president of the church, and businessman. He and his brothers owned the Trifelos Brothers Canton Confectionery on the main street downtown and the Liberty Theater in the southwest end. (Courtesy Mary Trifelos.)

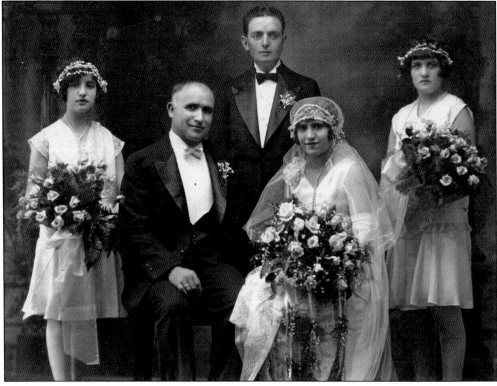

Peter Michalos was a native of Arfara, Greece. He arrived in the United States in 1906. During the Balkan Wars, he returned to Greece to serve in the cavalry. He met and married Margarita Vaitsis in 1912. He and his pregnant wife came to Canton in 1914. He worked at Canton Stamping and Enameling, rising to the position of night supervisor, but he found factory work did not suit him. He enrolled in barber school and opened the Royal Barber Shop (below) at 515 Tuscarawas Street East, operating the shop for 45 years. In the foreground, Michalos is giving James Marinos a haircut. Michalos was president of St. Haralambos Greek Orthodox Church three times during the 1930s. He was responsible for many interior improvements, including the replacement of the original tin ceiling with plaster. (Right, courtesy Tina Cotopolis; below, courtesy George Michalos.)

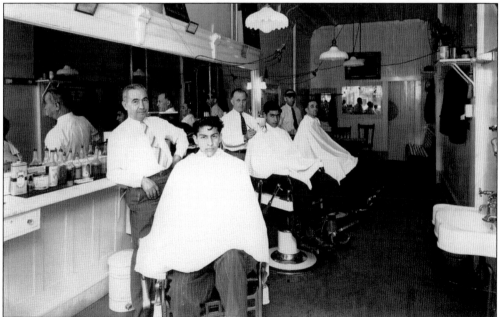

Petros Pimpas (standing at the left) brought his sisters Margaret and Angeline to this country. On October 22, 1922, Margaret married Anastasios Koufos at St. Haralambos Greek Orthodox Church. Angeline stands on the right next to her husband George Goglos (Agoglossakis). Daughter Freda sits in front. Goglos operated a poultry shop and grocery at 733 Cherry Avenue SE (below). At this premier poultry shop, Goglos paid special attention to quality and freshness. He bought live chickens from the Amish in Holmes County and kept them in coops in the shop. When a customer placed an order, Goglos killed and dressed the chicken in the alley behind the store. He is shown standing in front of his establishment. Later Goglos and his sister-in-law Margaret opened Quality Poultry Market at 602 Tuscarawas Street East. (Courtesy Mary Manolas.)

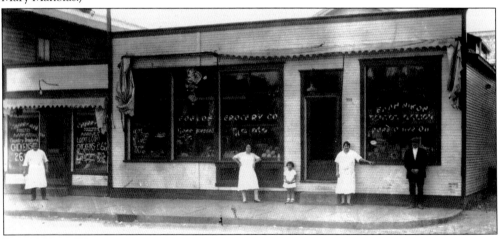

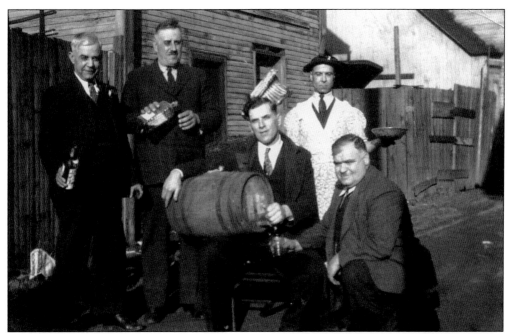

Anastasios Koufos (second from the left) made a new batch of wine every autumn from grapes ripening in large barrels in his basement. He would have a drink at dinner, on special occasions, and to entertain guests. Here he is sharing the wine with his brother-in-law George Goglos (kneeling at the right) and friends in the alley behind their home in the post-Prohibition 1930s. (Courtesy Mary Manolas.)

When the stock market crashed in 1929, the church owed more than $20,000 on the mortgage and barely avoided foreclosure. A colorful church leader during the difficult 1930s was Peter Norris (Panagiotis Nianiaris), who ran a lunchroom on Tuscarawas Street East. Shown here with his godson, he served as parish president in 1936. He was killed in an accident that police investigated because of his gambling connections. (Courtesy Mary Manolas.)

Fr. Gregorios Pantazonis of Samos served the two Canton parishes for almost half his 25 years in America. In 1935, when he was the priest at St. Haralambos Greek Orthodox Church, Archbishop Athenagoras visited and gave a special service to congratulate the parish for paying off its debt. In 1931, when the archbishop had visited Holy Trinity Greek Orthodox Church, Pantazonis had also been the priest there. (Courtesy Greek Orthodox Archdiocese of America.)

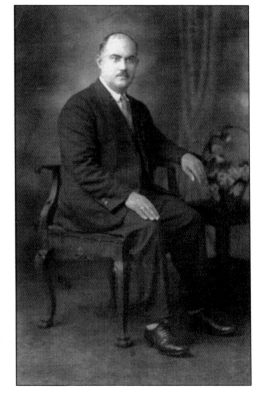

Peter Andrews (Panagiotis Andrutsopulos) accomplished the unusual feat of serving as president of both Canton parishes. He was one of seven who signed the St. Haralambos charter on January 23, 1915. He was the president of Holy Trinity in 1932 and the president of St. Haralambos in 1941. He owned a billiards parlor and bowling alley in the basement of the Strand Theater. (Courtesy Skendelas family.)

Anastasios Chuchanis arrived in Canton in 1903. He married wife Fotini in Greece in 1911. Shown here are their first three children; they would eventually have seven. Mary and John are taking the occasion seriously, but Ann is clearly enjoying herself. For many years, Anastasios, known as Andy, operated a fruit market at 607 Cherry Avenue SE, next door to his home. (Courtesy Janelle Kantzos.)

Gust and Vasiliki (seated at the right) Tzortzakis were among the first Greeks married in Stark County. In 1911, before the establishment of St. Haralambos, Fr. Parthenios Rodopoulos from Pittsburgh officiated. They are shown around 1925 with their five children and three cousins. Gust lost his poultry shop in the Depression. In 1935, he took over the Evergreen Grill at Sixth Street and Walnut Avenue NE. (Courtesy Esther Vagotis.)

Gust Manos (Manousakis) and Catherine Tsangarakis both lived in the southeast end near St. Haralambos Greek Orthodox Church. They were married by Fr. Chrysostomos Lavriotes on April 25, 1920. Gust was very musical, often playing the Cretan *lyra* at gatherings. Catherine had a beautiful soprano voice, and the children fondly remember their parents singing romantic songs to each other as their father played accompaniment. (Courtesy Mary Manos.)

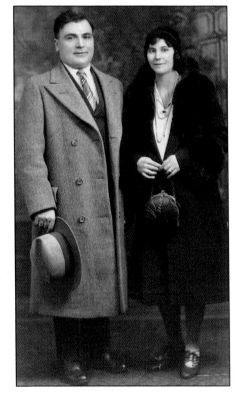

Constantinos Tsarwhas worked on the railroad and in the mills of Chicago, then settled in Canton. After buying a house and car and acquiring citizenship, he returned to Vlaherna, Greece, to marry. This photograph of happy newlyweds Constantinos and Helen Tsarwhas was taken in 1930. They lived on Dueber Avenue SW near the Timken plant where he worked. All her life, Helen prized the purse she holds. (Courtesy Theana Koutras.)

The striking Chrysanthi Georgiadou met Anthony Kallos in Smyrna, Asia Minor. Kallos came to the United States in 1924. She waited for him to get settled, joining him in 1927 in Steubenville, where they married. After more moves and many hardships, they arrived in Canton in 1930 with their eight-month-old daughter. Kallos had only 65¢ in his pocket, but compatriot Emmanuel Elite hired him as a cook. (Courtesy Mary Kallos.)

Anna and John Manos (Menounos) were married on March 10, 1921, in Akron. John had been working on the railroad in Montana and saved enough money to open a short-lived restaurant on Mahoning Road near the Windsor Theater. The couple lived close to the railroad tracks. Perhaps because of her husband's experiences in the West, she often fed hungry railroad men who were working nearby. (Courtesy Sam Manos.)

27

Sophia Peterson and William Effantis were married by Fr. John Petropoulos at St. Haralambos Greek Orthodox Church on July 23, 1939. William was serving on the church board of trustees at the time. They honeymooned in Akron for a few days, then got back to work at the Tip Top Grille. William operated the restaurant at 235 Tuscarawas Street East from 1929 until 1945. It was open from 7:00 a.m. to midnight, seven days a week. The photograph below was taken in 1943. William and Sophia are standing behind the counter. Their three-year-old daughter Joanne is being entertained by a wrestling promoter, who—along with his wrestlers at the nearby City Auditorium—was a regular customer. Although the restaurant was enlarged to accommodate 200 patrons, there were times when it was so full that William had to lock the doors. (Courtesy Sophia Effantis.)

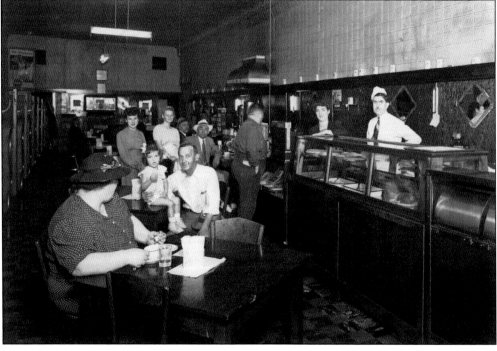

George Mannos (Mantzounis) ran the cigar and billiards shop that appears in the photograph below and also on page 10. The billiards parlor sponsored a semiprofessional football team in the 1920s that regularly won the local championship. The team played at Crystal Park, attracting crowds and generating good publicity. Mannos is, however, better known for his next establishment. After accumulating enough capital to enter the restaurant business, he opened Mannos Restaurant and Billiards at 336 Tuscarawas Street East. In 1935, it would be renamed the Golden Pheasant. It was a short-order place that was open 24 hours a day. It was famous for coneys, but Greeks would often stop by on Saturday morning, the only time that lamb's head, a delicacy, was available. (Right, courtesy James Mannos; below, courtesy Dr. John Mannos.)

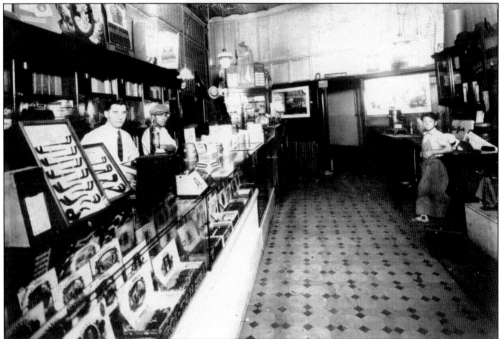

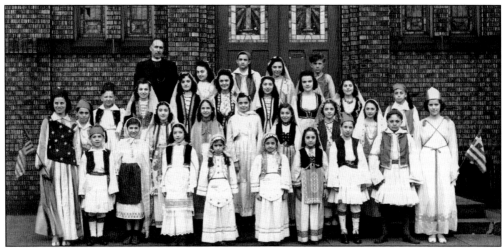

Greek school was held in the basement of the church daily after regular school hours. On March 25, the children dressed in traditional costumes to celebrate Greek Independence Day. In 1921, the 100th anniversary of the start of the war of Greek independence, there were church services, a parade through downtown Canton in which about 4,000 Greeks took part, and speeches in both Greek and English at City Auditorium. In 1939, about the time the photograph above was taken, the local Greek schools joined together to recite poetry and sing Greek patriotic songs. Many retain vivid memories of their teachers. One of them, Haritine Christu, is pictured below. A native of Nicosia, Cyprus, she immigrated in 1930. She also taught Greek for many years at Holy Trinity Greek Orthodox Church. (Above, courtesy Evelyn Eustathios; below, courtesy Canton Repository.)

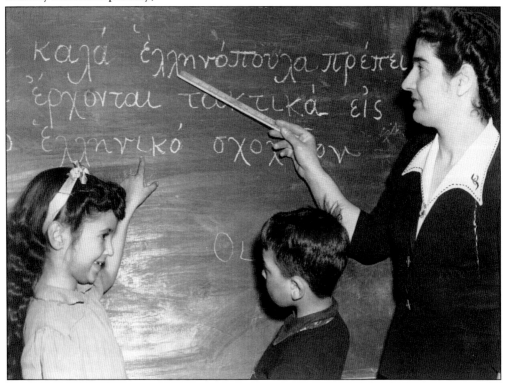

The basement of St. Haralambos Greek Orthodox Church was an all-purpose space in which Greek school was taught and social events were held. Here George Goglos (standing at the center) opens another bottle for the party. Later the space was partitioned with green curtains made by Sophia Effantis and others. It was used for Sunday school, which was instituted by Fr. Theophilos P. Theophilos, who served from 1949 to 1957. (Courtesy Mary Manolas.)

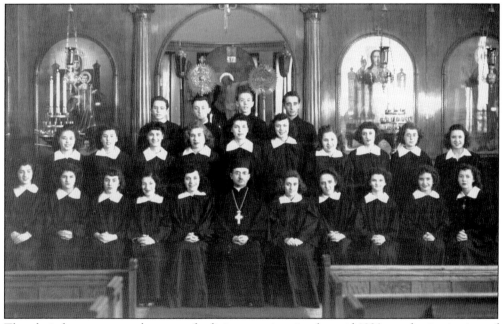

The choir became a regular part of religious services in the mid-1930s at the instigation of William Eustathios, who also purchased the organ. The first choir director was Helen Ekonomou. The first organists were Persephone Biris and Evelyn Eustathios, who began at age nine. In this 1946 photograph, the three people seated at the center are organist Lula Kallison (left), Fr. John Heliopoulos, and choir director Helen Argea. (Courtesy Betty Tsangeos.)

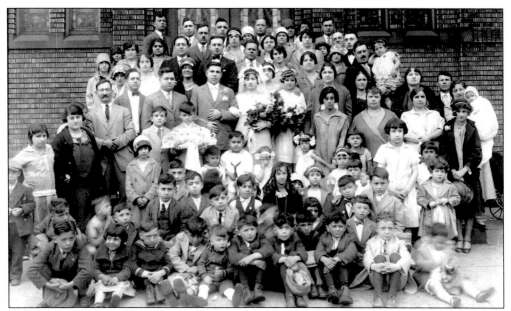

Christ Nickolas and Sylvia Mentzelos (Mentzelopoulos) were married on May 10, 1927. Although they had gone through a civil ceremony in France, Mentzelos considered herself single until they were married in church. The boy standing in front of the groom is displaying the wedding crowns worn during the ceremony. The many young children are an indication of the baby boom that occurred during the Roaring Twenties. (Courtesy Mary Manolas.)

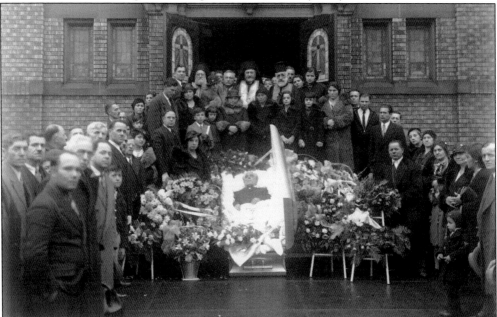

The funeral for 63-year-old Harry Economopoulos was held on January 9, 1935. The proprietor of the Evergreen Grill at Sixth Street and Walnut Avenue NE, he had lived in Canton since 1920. His widow, Frosini, stands beside the coffin. Fr. Chrysostomos Lavriotes returned to Canton from Cleveland to conduct the funeral. Fr. Gregorios Pantazonis, the priest of St. Haralambos Greek Orthodox Church, is standing beside the door on the left. (Courtesy Esther Vagotis.)

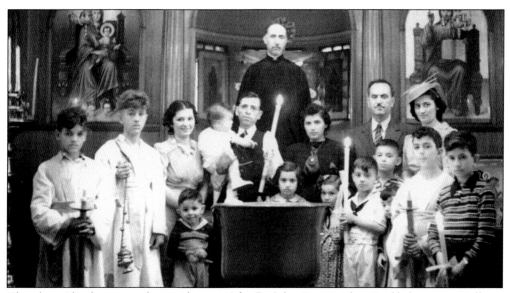

Theodore Chuchanis was baptized in 1940 by Fr. John Petropoulos. Godfather Gust Gallanis holds the baby behind the baptismal font. Theodore's parents, Gust and Sylvia Chuchanis, stand beside Gallanis on the right. Theodore's sisters, Esther and Georgene, are looking out from behind the font. Gust Chuchanis owned the American Poultry Company at 412 Second Street SE, supplying chicken to the community for 33 years. (Courtesy Georgia Pagonis.)

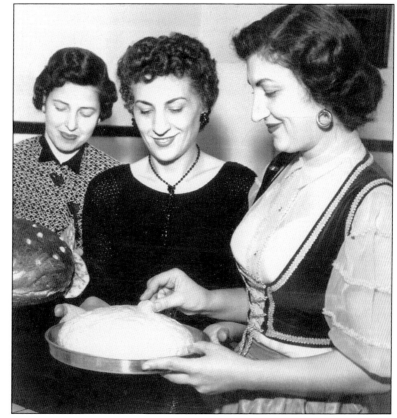

St. Haralambos Sunday school teacher Sophia Effantis, in a traditional vest borrowed from Mary Elite, inserts a coin into an unbaked loaf held by her sister Freda Kallas, while good friend Despina Tremoulis holds the finished product. The custom is to slice the Vasilopita (St. Basil's bread) on New Year's Day. The person who receives the coin will have good luck during the coming year. (Courtesy Canton Repository.)

Stavros Stamoules, who was working in a Kentucky coal mine, married Brasky Moore in 1923. Greek men who married non-Greek women often left the church community. Brasky, however, became thoroughly assimilated. She learned Greek, cooked tasty Greek food, and later married in the Greek church. They are seen here with their first son, George, who died in 1933, shortly after this photograph was taken. (Courtesy Steve Stamoules.)

Six-feet-two-inch-tall Panagiotis Bascos (Basiakos) ran a bar and restaurant in Marion, returning to his native Stemnitsa in 1928 to marry Maria Bellas. The next year, daughter Nancy (Athanasia) was born. In 1938, they went back to Greece. After war devastated the country, they returned to Ohio. Panagiotis ran a poolroom and cigar shop in Mount Vernon until John Anderson suggested a move to Canton in 1950. (Courtesy Sylvia Stamoules.)

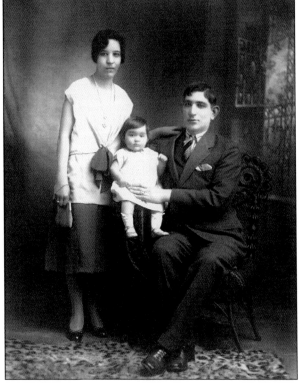

George Sousaris worked in the United States, often returning to Chios to see his wife Kalliope and their sons. By 1940, he was living in Canton, where his brother Michael ran Liberty Hat Cleaning. George later opened his own shop next to the Valentine Theater. After a damaging earthquake in Chios, George's family joined him. Many immigrants from Chios became part of the postwar community of St. Haralambos Greek Orthodox Church. (Courtesy Dolly Sousaris.)

Constantinos Xides earned his American citizenship by serving in the army in World War I. After operating a billiards parlor in Pittsburgh, he returned to Stemnitsa, married Sophia Roukema, and settled down to farm. In 1946, after World War II, he brought his family to the United States. They are shown here not long after their arrival. They lived first in Pittsburgh, then settled in Canton. (Courtesy Catherine Darrah.)

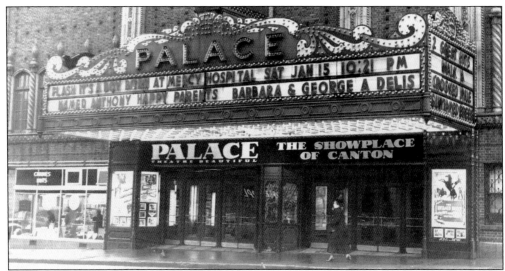

One new Greek arrival had his name in lights. On January 15, 1949, George Delis, who ran the Palace Theatre on Market Avenue North, proudly announced his son's birth on the marquee. Anthony "Flash It's a Boy" Delis has made a more lasting impression than the "2 Great Hits" that shared the marquee. (Courtesy Anthony Delis.)

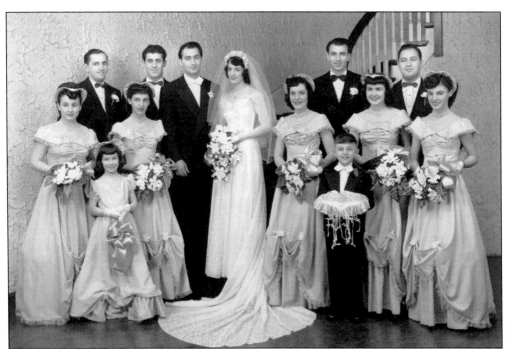

The wedding of Paul Pappas and Katherine Mottas was held at St. Haralambos Greek Orthodox Church on January 23, 1949. This was a "mixed marriage" between the son of the first elected president of Holy Trinity Greek Orthodox Church and the daughter of a prominent St. Haralambos family. Priests from the two churches officiated. As such marriages became more common, relations between the two parishes continued to thaw, settling into a friendly rivalry. (Courtesy Maroula Mottas.)

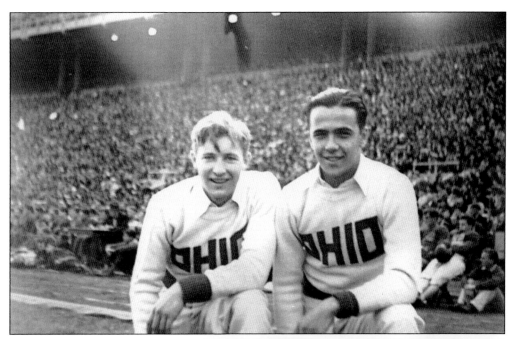

George Michalos is shown above (on the right) as an Ohio State University cheerleader. Harry Paulos is shown in the photograph to the right. In 1957, engineers Michalos and Paulos, along with businessman John Kiminas, were members of the St. Haralambos Building Committee. The neighborhood had changed, and the parish was considering building a new church. Property was purchased. The building committee, however, suggested that instead of building a new structure, the parish should move the existing church building. After considerable research, plans were made to cut the church in two, navigate it through the streets of Canton, and use it as the basis for a new church with double the seating capacity. There were many risks, but the people of the parish united behind the decision, placing their faith in these men. (Above, courtesy George Michalos; right, courtesy Mary Trifelos.)

On June 14, 1958, spectators gathered to watch as the 350-ton front end of the church began to move along a four-mile route through the heart of Canton. The process would take 18 days. Obstructions along the route, including electrical and telephone wires, had to be removed. Policemen directed traffic at intersections where, as shown here, the traffic lights had been taken down. (Photograph by Joseph Manolas.)

Moving the church meant that hundreds of precious icons, liturgical items, and other valuables had to be moved. The five-tiered crystal chandelier had been imported from Czechoslovakia and required special handling. Here Fr. Leon Pachis, who served the parish from 1957 to 1960, is being briefed. The chandelier was moved without incident and rewired. It continues to illuminate the church today. (Photograph by Joseph Manolas.)

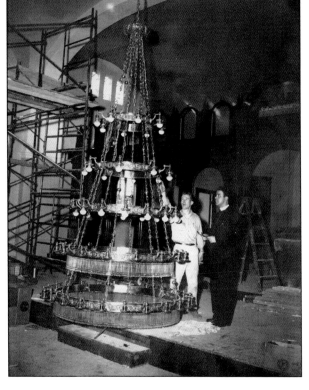

Two

HOLY TRINITY GREEK ORTHODOX CHURCH

Many of the parishioners of Holy Trinity Greek Orthodox Church were immigrants from the Pontos coastal region of northeastern Asia Minor. Most Greeks came to the United States in search of a better life, but those from Asia Minor came to save their lives. In the second decade of the 20th century, young Greek men were dying in Ottoman labor camps. Many others left their homes and families and fled to the United States.

With the outbreak of World War I in 1914, political tensions divided every sizable Greek community. In Canton, supporters of Greek prime minister Eleftherios Venizelos broke away from St. Haralambos Greek Orthodox Church at Easter 1917, speedily establishing the new parish of Holy Trinity. They built in the northeast end, where many immigrants from Asia Minor had found employment in the steel mills. Completed in October, this was the first Greek Orthodox church constructed in Stark County. Remarkably, the mortgage was paid off within three years.

After 1922, there was a massive population exchange of Greeks living in Asia Minor for Turks living in Greece. Many of those who survived had lost everything, and some of them came to Canton. As the community grew, more space was required. Koraes Hall, completed in 1927, was the first Greek cultural center in the county. During the Depression, nearly all the parishes that had split apart over politics reunited, but Holy Trinity had no mortgage debt and was able to remain independent.

After World War II, a new wave of immigrants found work at the steel mills and settled around the church. Within a generation, however, the neighborhood changed. The parish decided to build a new church in the suburbs. For those who had lost their homes in Asia Minor, this additional uprooting brought a sense of loss. Land on Fairhaven Avenue NW was purchased in 1967. On May 28, 1972, the cultural center was dedicated. The first services held in the new church were at Easter 1977. Although parishioners still speak fondly of the church-centered Carnahan neighborhood in which they grew up, the new church and cultural center have served the parish well for 30 years.

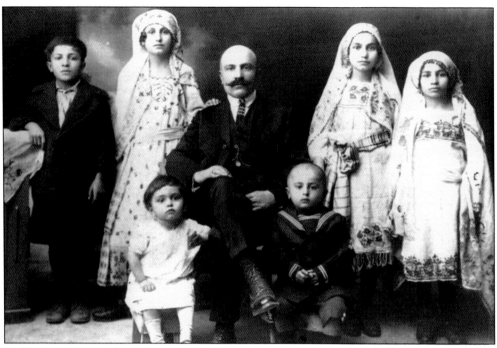

Eleftherios Sideropoulos is shown here with his son George (at the far left), his daughter Martha (at the far right), and his nieces and nephew. In 1912 and 1913, vast numbers of Greek Orthodox men left Asia Minor, with some, like Sideropoulos, seeking refuge and work in Stark County. Although they exchanged letters, it would be 15 years before his family would be able to join him. (Courtesy Theodosia Spewock.)

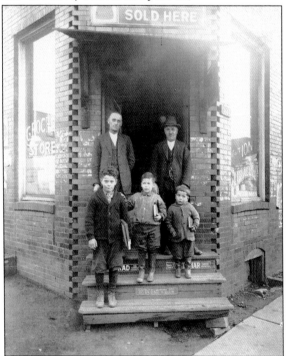

Small Greek businesses catering to the immigrant mill workers soon appeared. At the corner of Carnahan Avenue and Tenth Street NE, John Andreadis, an immigrant from Ordou, opened one of the first groceries. In 1925, he was photographed (standing on the right) on the steps with his three sons and his brother Nikolaos. His was one of the few Greek families in this area before 1920. (Courtesy Andrew Andreadis.)

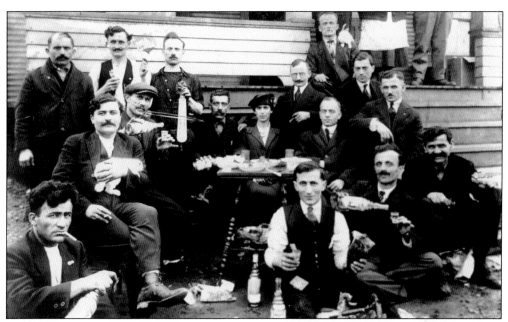

The surge of immigrants created a housing shortage in Canton. Large boardinghouses soon sprang up near the mills. In the autumn of 1913, the Canton Board of Health found one nine-room house with 82 men sleeping in shifts. As yet, few Greek women had come to Canton. Here men enjoy wine and song outside a boardinghouse, but with only one woman and—oddly—two rabbits. (Courtesy Nick Spondyl.)

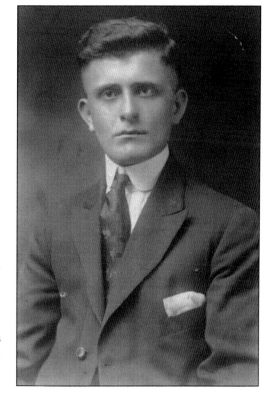

Most of the immigrants were young single men. They had been most at risk of being forced into Ottoman labor camps. They were also the preferred cheap labor for American factories. Gust Godagidis arrived in 1913 at age 18. He, like many others, had escaped the Balkan Wars of 1912 and 1913 but within five years ended up serving in the American military in World War I. (Courtesy Meta Hasiotis.)

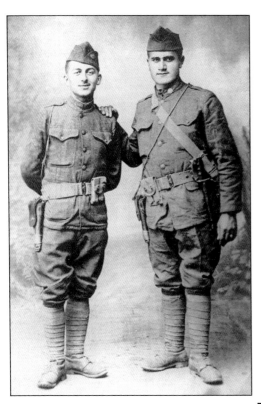

The United States entered World War I on April 6, 1917. On May 1, over two dozen Greek immigrants, including Kiriakos Papadopoulos (on the left) and Anastas Heropoulos, enlisted in the United States Army. This was front-page news, the first positive secular publicity about the local Greek community. Many Greeks saw this as an opportunity to fight the hated Turks. Those who served received American citizenship. (Courtesy Argery Giavasis.)

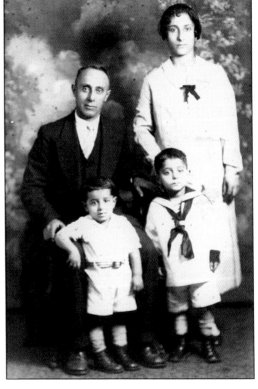

With the onset of war, politics tore the parish of St. Haralambos Greek Orthodox Church apart. Parishioners from Asia Minor were maligned as "Turks." Royalists were demeaned as "pro-German." Five men from Messoudie in Asia Minor led a breakaway group to form the new parish of Holy Trinity Greek Orthodox Church. The split was formalized on Easter Sunday 1917. Louis Korosedes, shown here with his family, signed the charter and served as the first president. (Courtesy Mary Steve.)

The new parish acted swiftly. It purchased property at the corner of Ross Avenue and Tenth Street NE. On May 27, ground was broken. For an enormous contribution of over $3,000, Theodore Aslanides was awarded the privilege of laying the cornerstone. The elaborate ceremony was witnessed by more than 2,000 people. Aslanides is shown with his wife Peristera (seated), their godson Tommy, and Tommy's mother Catherine Eleftheriades. (Courtesy Elizabeth Tarzan.)

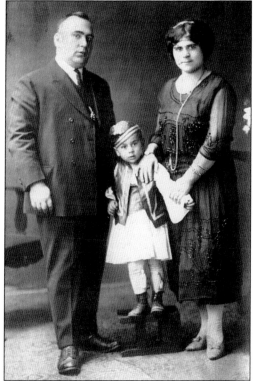

Fr. Simeon Mitatakis, the first priest of Holy Trinity, arrived on September 15, 1917. On November 25, he performed the first recorded marriage of the new parish, uniting Muratios Muratides and Fotini Janidou. They are shown here in a later photograph with their son George. Construction of the church was complete, but it would take several years before all the interior decoration was finished. (Courtesy George Muratides.)

Holy Trinity Greek Orthodox Church was built in less than six months on an undeveloped part of the floodplain close to Nimishillen Creek. George Karipides stands proudly (although not in focus) in this earliest-known photograph of the completed church. After the war, homes were built all around the church, and the neighborhood teemed with life. Karipides and his wife Anatoli raised their four children just down the street. (Courtesy Magdalene Pousoulides.)

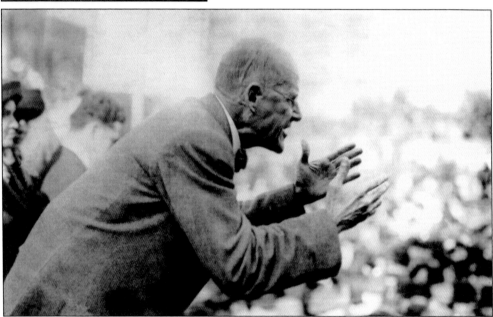

On Holy Trinity's name day, June 16, 1918, the first anniversary of the establishment of the parish was celebrated in the recently completed church. Just a few blocks away at Nimishillen Park, at the state Socialist convention, activist Eugene V. Debs was delivering his famous speech critical of American involvement in the war. He was arrested and sentenced to 10 years of imprisonment. (Courtesy Eugene V. Debs Foundation.)

44

Theofilos Pappas is shown (seated at the right) with his extended family. Married in 1905 in Messoudie, he arrived in Canton in April 1913. He ran a thriving produce business. As the first elected president of Holy Trinity, he raised money for the church on weekends. He would place a cross and a $20 bill on a tray and make the rounds of the coffeehouses asking for donations. (Courtesy Paul Pappas.)

On June 13, 1920, the $50,000 church mortgage was burned. This was remarkable since most parishioners were factory workers who made no more than 30¢ an hour. Andrew Nickas, who was in charge of parish financial transactions, gave a speech at the ceremony. He had risen to second lieutenant in the army during World War I and later became the first Greek attorney in the county. (Courtesy Joanna Palacas.)

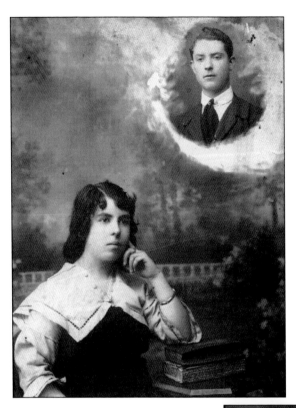

After the war, the seas were safe from U-boats, and ocean liners again offered passage. Among the early arrivals in Canton were George and Irene Macrides. Irene was Spanish. Her father owned a mattress factory where George was employed. Despite parental opposition, she would rendezvous with him during walks with her chaperone. She is pictured thinking of her beloved. Irene and George were married on January 16, 1920, in Constantinople. (Courtesy George Macrides.)

Pelagia Janidou was the last of her siblings to immigrate to the United States. Her two sisters, Fotini Muratides and Chryssi Andreadis, and her brother Panagiotis had already settled in Canton. Janidou and her niece Dorothea arrived in 1921. On September 10, just a few months later, Janidou married Stat John Navrozides, who had been working in the United States since 1913. (Courtesy George Naves.)

John and Helen Lazarides were married in Russia in 1909, and John arrived in Canton in 1913. It was not until 1921 that Helen and their nine-year-old son George were able to join him. By this time, John was a prosperous grocer and church leader. There was an 11-year gap between the birth of their son and their second child, Peggy. (Courtesy Georgia Pavlis.)

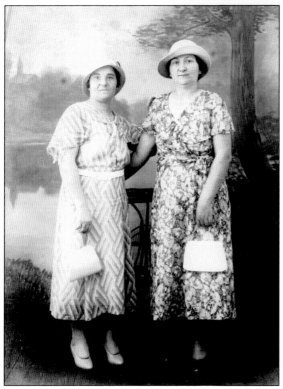

After Harry Manos (Manoussarides) was discharged from the army, he traveled to Constantinople, where he married Despina (on the right) in the summer of 1920. They soon settled in Canton. Her cousin Vasiliki arrived the following spring and married local entrepreneur Eleftherios Beftoulides at Holy Trinity Greek Orthodox Church in May 1921. For years, they would live across Irwin Place NE from each other, just one block from the church. (Courtesy William Beftoulides.)

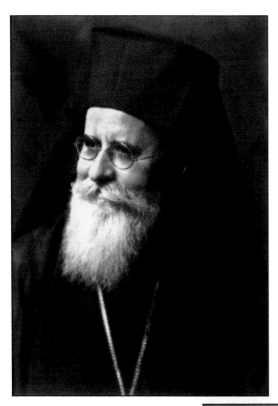

On May 28, 1922, Archbishop Alexander, just two weeks after being officially elevated to archbishop of North and South America, came to Canton for the consecration of Holy Trinity. Priests from all over northeast Ohio, as well as local politicians and dignitaries, attended. After the services, at a banquet held in his honor, he discussed the plight of Greek Christians in Asia Minor. (Courtesy Greek Orthodox Archdiocese of America.)

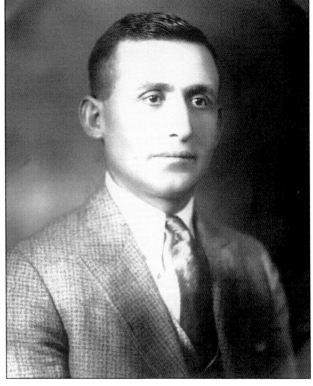

Philip Papadopulos was a produce wholesaler who sponsored many Greek immigrants applying for citizenship. He was also a partisan who named his firstborn Venizelos. He helped organize a mass rally at City Auditorium on January 1, 1919, calling for the freedom of the three and a half million Greeks still living under Ottoman control. Papadopulos also sent a telegram pressing their demands to British prime minister Lloyd George. (Courtesy Philip V. Papadopulos.)

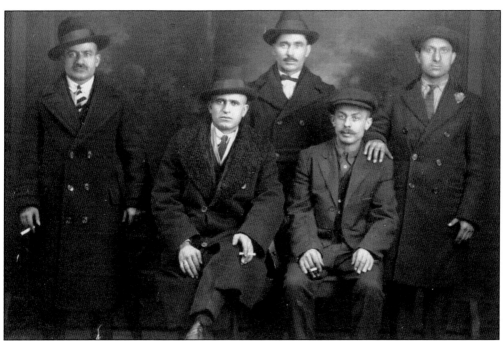

On July 1, 1924, a law to limit immigration from Greece to 100 people per year was scheduled to take effect. Noncitizens working in the United States would no longer be able to bring their families to join them. Nicholas Kalagidis (seated on the left), Nicholas Janikides (seated beside him), and three friends set sail for Greece on March 11 to beat the deadline. By May 31, they brought their families back aboard the SS *Madonna*. Olympia Kalagidis (on the left in the photograph to the right) was reunited with her husband after 11 long years, but two of their daughters had been kept from boarding for medical reasons. In Canton, they would have two more children, but Olympia would not see one daughter for 11 years, and she would never see the other again. (Courtesy John Kalagidis.)

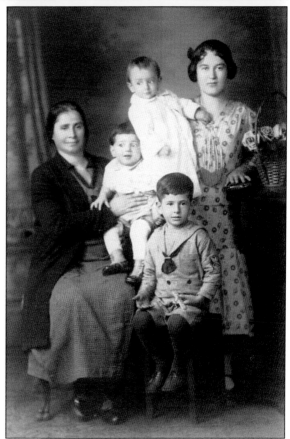

George and Anatoli Karipides married in Ordou in 1910, and George came to the United States in 1912. He was not able to bring his wife to the United States until he became a citizen. In 1925, after a separation of 13 years, Anatoli was able to join him. They are shown with three of their four children: (from left to right) Magdalene, Dimitrios, and Parthena. (Courtesy Magdalene Pousoulides.)

In June 1926, Katina Koinoglou (Americanized as Stutz), her mother, and sister arrived in Canton, where her father was working. She could not speak English and had to attend school with much younger children, which was difficult for her to bear. Stutz is shown here at the back in her third-grade class photograph. In June 1930, after completing fifth grade, she and Efstathios Simionides were married at Holy Trinity Greek Orthodox Church. (Courtesy Bessie Samuels.)

Fr. Ioakeim Doulgerakis arrived in the United States in 1923 and in 1925 became the eighth priest to serve Holy Trinity. He was a driving force behind the establishment of the Greek school and Sunday school and the construction of Koraes Hall. He also has the important distinction of being the priest who started keeping the register of weddings, baptisms, and funerals. (Courtesy Greek Orthodox Archdiocese of America.)

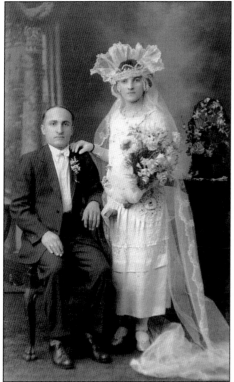

On January 10, 1926, Father Doulgerakis officiated at the wedding of Olga George and Steve Adams at the bride's home. The wedding feast for 100 was held at the groom's home. According to an article by fellow parishioner Paul Masters in the *Canton Daily News*, the guests consumed 300 pounds of spring lamb and 20 cases of near beer. The celebration continued into the morning hours. (Courtesy Sophie Adams.)

After World War I, women began to arrive, and the demographics of the parish changed. Starting in 1920, the number of baptisms increased each year. They peaked from 1926 to 1928, when nearly 200 were performed. Because of the baby boom, the church needed more space. Shown here around 1924 are Mary and Nicholas Andreadis, children of grocer Harry Andreadis and his wife Evropi. (Courtesy Peggy Hadjian.)

Because of immigration restrictions, there were few single Greek women in Canton. Weddings held at Holy Trinity Greek Orthodox Church declined from a high of 20 in 1923 to only 3 in 1928. Harry Kiryakides was one of many men who earned his citizenship then sailed for Greece to marry. In February 1930, he was united with Elizabeth Gounopoulos in Athens. Her two sisters were already living in northeastern Ohio. (Courtesy Bertha Macrides.)

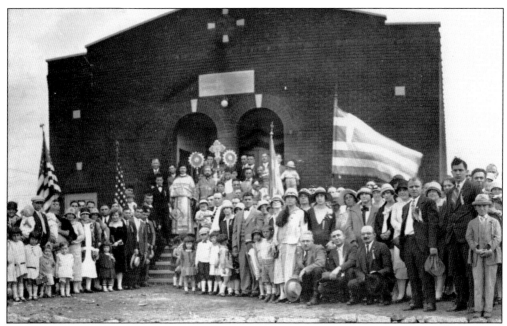

Bishop Philaretos came to Holy Trinity on June 12, 1927, to celebrate the 10th anniversary of the parish and the laying of the cornerstone for Koraes Hall, the first Greek Orthodox cultural center in Stark County. The building cost $15,000 and included an auditorium, gymnasium, and banquet room in the basement. As shown here, the bishop returned on September 11 to dedicate the building. (Courtesy Holy Trinity Greek Orthodox Church.)

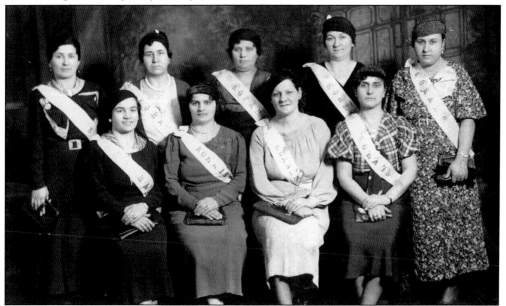

The Koraes Ladies Society was established in 1927. Its first major event was the banquet in June of that year honoring Philaretos, the first bishop of the Chicago diocese and the first with direct jurisdiction over Stark County. During the Depression, as other breakaway parishes succumbed to financial pressure and reunited with their home parishes, the Koraes Ladies Society helped Holy Trinity maintain its independence. (Courtesy Koraes Ladies Society.)

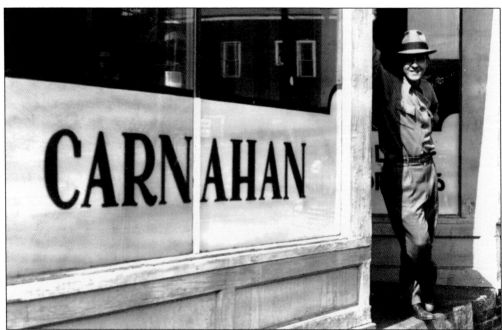

Holy Trinity Greek Orthodox Church was located in the Carnahan neighborhood, and most parishioners lived nearby. The area was named after John E. Carnahan, who, in 1901, was one of the three richest men in the city. A Pennsylvania industrialist, he had been given inducements to build a tinplate factory in Canton. This laid the foundation for the expansion of industry in the northeast end, which also spurred residential development. The main street of the neighborhood was Carnahan Avenue, where Alexander Zouncourides (shown above) later operated a billiards parlor. The popular Constantinople Restaurant (below) was located at the intersection of Carnahan Avenue and Tenth Street. People came from all over the city to dine. Owners Steve Orphanides (on the left) and Nicholas Spondyl pose behind the bar with two waitresses. (Above, courtesy Anna Zouncourides; below, courtesy Nick Spondyl.)

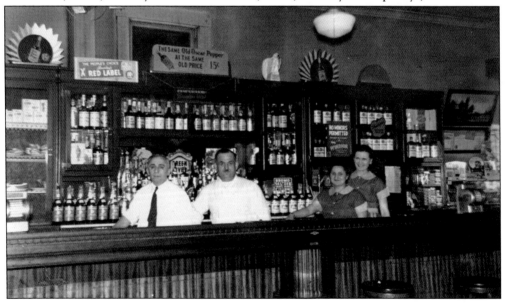

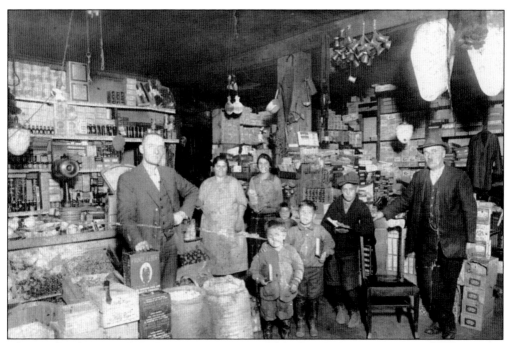

John Andreadis opened the first grocery in the neighborhood when Carnahan Avenue was still a dirt road. Previously food and dry goods had been sold from horse-drawn wagons that made the rounds. As shown in this photograph from 1925, Andreadis also sold kitchen utensils, notions, and clothing. He learned the trade from his father, who had sold yard goods in Asia Minor. (Courtesy Andrew Andreadis.)

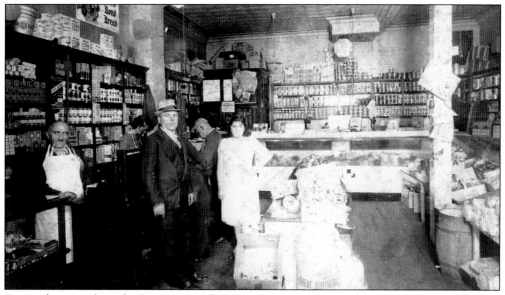

Across the street from the Constantinople Restaurant was the Lazarides Grocery. Harry Lazarides settled in Canton in 1913 but was not able to bring his wife and son to Canton until 1926. His shop specialized in lamb, which he sold in great volume at Easter. He stands behind the cash register. Daughter Mary Lazarides is at the right, and friend George Yamakides stands in the center. (Courtesy Kathryn Lazarides.)

Archbishop Athenagoras arrived in the United States in February 1931 as the second archbishop. Of the numerous Greek Orthodox churches named Holy Trinity in this country, he chose to celebrate his first Pentecost at Holy Trinity in Canton. The services were attended by priests from all over northeast Ohio. It was the first of the archbishop's many trips to both Holy Trinity and Stark County. (Courtesy Greek Orthodox Archdiocese of America.)

In the early years, infant mortality was high. Children fell victim to poor medical care, ignorance, and accidents. In the Holy Trinity community, one child died after eating a raw potato, while another fell out of a high chair. Six-year-old Nancy Manos, shown here between her brother and sister, lost her life on October 4, 1931, when children playing with matches accidentally set her clothing on fire. (Courtesy Elizabeth Tarzan.)

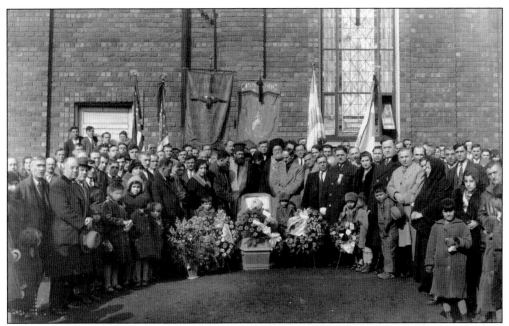

Before unions improved working conditions, industrial accidents were a major cause of death. On February 19, 1932, a tank of sulfuric acid turned over onto Savas Turnides. He died, leaving a wife and three children in Greece. Here he lies beside the church he loved. His brother Panagiotis died two years later, the victim of a work-related respiratory disease. (Courtesy Evelyn Romeo.)

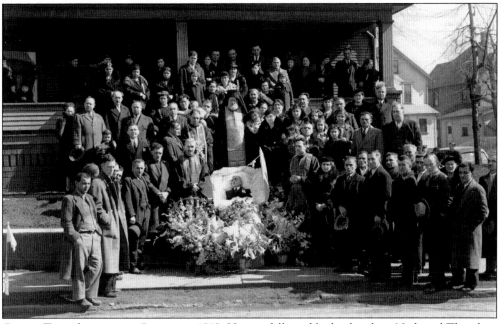

George Tatarides came to Canton in 1912. He was followed by his brothers Nick and Theodore in 1913 and his sister Parthena in 1921. He operated a produce market on Mahoning Road NE. George died on March 7, 1938, at age 52. His body lay in state at home, where mourners could pay their respects, before being transferred to the church. Fr. Artemios Stamatiades conducted the funeral. (Courtesy Sophie Pergins.)

In 1920, Haralambos Gotides came from Asia Minor to join his cousin, Nicholas Spondyl. Gotides's wife Parthena arrived in Canton in 1927 and died of pneumonia within three months. He and their daughter Athena stayed on, but during the Depression, he was forced to look for work elsewhere. In 1935, he married Eleni and moved to Wilmington, Delaware. This family photograph was taken about 1940. (Courtesy Virginia Gotides.)

Constantinos Hadjian, a native of Ordou who was working in Canton, was joined by his wife Magala and son Theodore in 1922. Theodore (at right) attended J. J. Burns Elementary School and McKinley High School and was one of the community's first high school graduates. In 1932, he moved to Poughkeepsie, New York, where he studied the accordion. He returned to Canton in 1936 and trained a 25-piece accordion band. (Courtesy Peggy Hadjian.)

Since there were few single women in the early community, many men were unable to marry. These bachelors had considerable disposable income and played an important role in building the church. They were fixtures at the coffeehouses, where children could count on their generosity at Christmas and other holidays. Some, like Constantinos Anifantes, stayed in Canton only a few years. He arrived in 1920, boarded with Sam and Anastasia Samonides, and baptized their son Joseph. Like many others, Anifantes returned to Greece during the Depression. He left behind little except a few photographs and a suit for his godson. Some bachelors were known only by their nicknames. Christ Thomaïdes (below), perhaps because of his imposing girth, was called "Kaimakan," a Turkish term referring to the grand vizier and governor of Constantinople. (Right, courtesy Joseph Samonides; below, courtesy Bessie Samuels.)

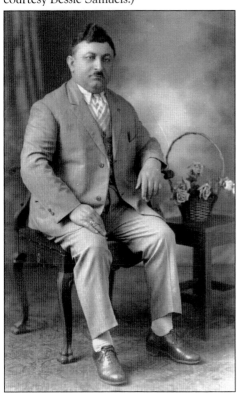

Born in Crete, Gust Maragakes arrived in Quebec in 1913 and entered this country by train at Detroit. He worked in several places before settling in Canton. After becoming a citizen, he asked his fiancée Penelope to meet him in Marseilles, France, where they were married on November 11, 1925. Helen (shown here) was the youngest of their three children. She was born on Christmas Eve 1939. (Courtesy Helen Tsarwhas.)

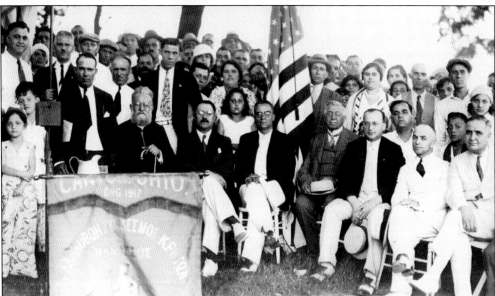

Many Cretans attended Holy Trinity Greek Orthodox Church, feeling at home in a parish that strongly supported Prime Minister Eleftherios Venizelos, who was Cretan. The Knossos Society, which is still active today, was founded by Cretans in 1917. Gust Maragakes was among the charter members. Its annual picnics were attended by everyone in the community. At this picnic around 1933, Fr. Gregorios Pantazonis sits behind the banner, flanked by dignitaries. (Courtesy Paul Pappas.)

Esther (Efstratia) Papadopoulos and William Dimetriou are seen here in 1930, after they eloped to Cincinnati. Both Esther and William were from the Brusa area, not far from Constantinople. Her father, Peter, had already left for America when she was born. He eventually reached Canton, where he ran a barbershop on Carnahan Avenue. In 1928, Esther and her mother were finally allowed to join him. (Courtesy Ann Manos.)

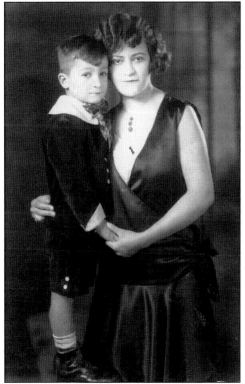

Sultana and Theophilos Papachristou were married in 1922. She was from Strantza in eastern Thrace near Constantinople. She is shown here with their son Nicholas, who was born in 1925. Sultana was active in the parish, serving as the second president of the Koraes Ladies Society in 1928. The family later moved to the steel town of Weirton, returning to Canton after Theophilos died. (Courtesy Sophia Klide.)

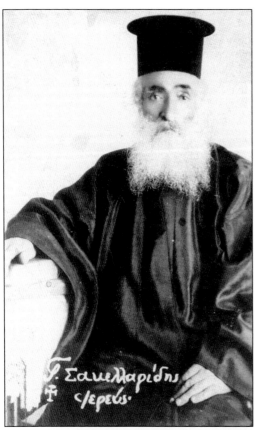

A native of the island of Carpathos, Fr. Georgios Sakellarides served Holy Trinity Greek Orthodox Church from 1932 to 1937, when construction of the annex connecting Koraes Hall with the church took place. This photograph was taken in 1937 and sent from his new parish in West Virginia to Eleftherios Beftoulides, who had been director of the Sunday school and president of Holy Trinity during Sakellarides's tenure. (Courtesy William Beftoulides.)

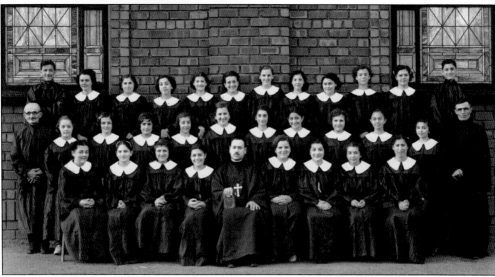

This photograph was taken around 1937, the year after the Holy Trinity choir was organized. The first choir director was Helen Ekonomou. Sophie Athens (third row, sixth from the left) accompanied the choir on a pump organ. Despina Mahairidou, the second choir director, sits to the right of Fr. Demetrios Mittakos. Previously Nick Athens and Harry Markakis had organized choirs that only sang on special occasions. (Courtesy Audrey Tsilidas.)

Fr. Artemios Stamatiades served Holy Trinity for only four months in 1938, but he left a powerful impression. He had come to the United States from a monastery in Jerusalem. After 10 years, he was called to organize the new Greek Orthodox diocese in Mexico. Following that assignment, he came to Holy Trinity. He was later elevated to archbishop in the patriarchate of Jerusalem. (Courtesy George Rafailedes.)

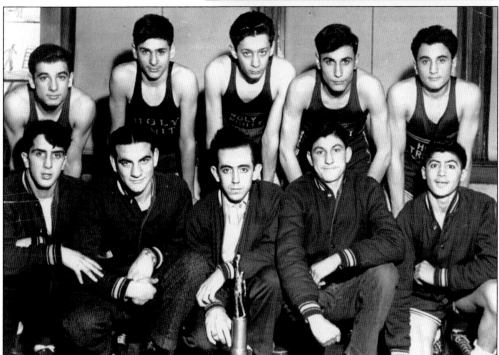

Sports were an important part of parish life. Here the Holy Trinity basketball team poses after winning the church league about 1937. The team practiced on the streets with a bottomless bushel basket attached to a telephone pole. Later "Big John" Gust, a major benefactor of the parish, offered to pay the $2 rental fee for a school gymnasium if every team member attended church every Sunday. (Courtesy George Rafailedes.)

George Rafailedes of Canton and Lula Pachares of Akron were engaged in February 1942. This photograph was taken in March, when George came home from boot camp before being sent overseas. He served in the navy as a seaman first class aboard the USS *Sailfish* in the Pacific. After their extended engagement, George returned home safely and married Lula in Akron on May 19, 1946. (Courtesy George and Lula Rafailedes.)

Before the war, Lazer Tarzan (shown here in navy uniform) and friends traveled to Indianapolis to enter a military training school. Although Lazer was an excellent gymnast, he failed the physical because he was underweight. A friend suggested he quickly stuff himself with bananas, but Lazer declined. Months later he was in the navy. He earned 17 battle stars for service in the Atlantic and Pacific theaters. (Courtesy Lazer Tarzan.)

George Kirman came to the United States on the SS *Madonna* in 1924. He joined the army in May 1943 and married Anna Anastas at Holy Trinity Greek Orthodox Church on January 16, 1944. Kirman was killed in action on March 25, 1945, just days before the war in Europe ended. He was buried at Lorraine American Cemetery in France. Six Stark County Greeks lost their lives during the war. (Courtesy Georgia Kirman.)

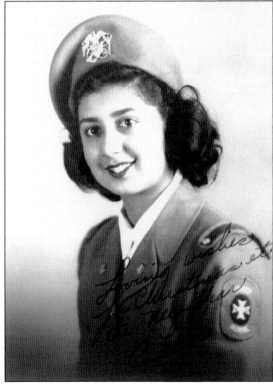

Nurse cadet Christine Lemonopoulos trained during World War II. Her family, though not Orthodox, played an important role in the Carnahan community. Her mother operated a dry cleaning and alteration shop. She also taught Greek in her home and read letters for neighbors who could not read themselves. Their family was one of many that left Canton for Florida around the time of the war. (Courtesy Peggy Hadjian.)

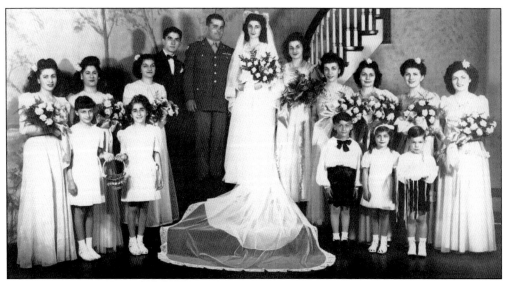

On June 17, 1945, Peter Tsaftarides, who was home on leave from the army, married Helen Aslanides. Theodore Tsaftarides, the groom's 15-year-old brother, was best man. Because of the war, there were no other men in the bridal party. During the last two years of World War II, there were four weddings held at Holy Trinity Greek Orthodox Church. After the war ended, there were 34 weddings in two years. (Courtesy Maroula Mottas.)

This photograph of the Nick and Athena Zantopoulos family was taken in 1943 just days before George, standing behind his parents, was to enter the U.S. Army Air Force. Bertha was only seven years old and did not understand why her mother could not stop crying. In 1946, the family moved to California, as did several other Canton families. Athena had never liked the Ohio climate. (Courtesy Bertha Marshall.)

Eugene Klide (Eugenios Klidoniaris) returned to his native Samos in 1929 to marry. He is shown in 1930, seated beside his pregnant wife Maria. In 1938, during the Depression, he took his family to Samos but was soon forced to return to Canton. During World War II, he was separated for seven years from his family, who endured great hardship before returning to Canton in 1946. (Courtesy Angie Anastas.)

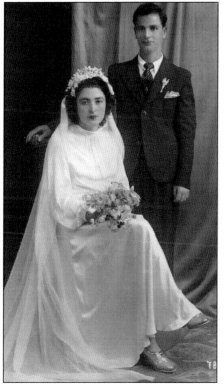

Helen and Gust Christopher (Constantinos Christoforou) were married in the village of Kiti in Larnaca, Cyprus, in 1944. Gust's sister Christina Stilianos had been living in Canton since 1929. In 1950, Gust and Helen brought their four young children to Canton. The arrival of a new wave of immigrants after the war would invigorate the parish and keep the Greek language and traditions strong. (Courtesy Gust and Helen Christopher.)

Lazaros Anastas is shown here with his sons Basil (left) and Sam. Lazaros had come to the United States in 1913, becoming a citizen in 1924. He returned to Greece in the late 1920s. He brought his sons to the United States in 1948, fearing what might happen to them in the Greek Civil War. Basil and Sam settled in Canton, becoming businessmen and community leaders. (Courtesy Angie Anastas.)

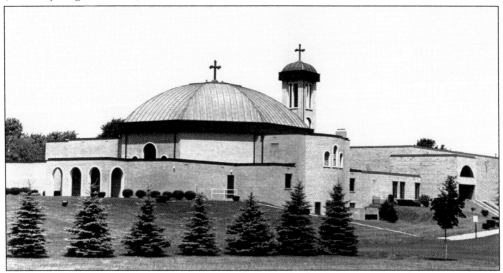

By the 1960s, the Carnahan neighborhood had changed. The decision was made to deconsecrate the church and rebuild on a spacious site in the suburbs. By Easter 1977, a new Holy Trinity Greek Orthodox Church opened its doors. Many parishioners, however, still feel a sense of loss and yearn for the old church and neighborhood, just as their parents lamented their lost homeland in Asia Minor. (Courtesy Holy Trinity Greek Orthodox Church.)

Three

ST. GEORGE GREEK ORTHODOX CHURCH

The Greek community established itself early in Massillon, but the population was always smaller than in Canton. Weddings, baptisms, and funerals were either held at churches in Canton, or priests came to Massillon to perform the ceremonies. It was not until the formation of the Massillon chapter of the American Hellenic Educational and Progressive Association (AHEPA) in June 1926 that there was a major move to organize a parish. St. George Greek Orthodox Church was established in 1931, within a few weeks of the arrival in America of Archbishop Athenagoras, who seemed to take a special interest. Because St. George was formed later than the Canton parishes, it did not have to contend with the same explosive political passions.

The first priest, Fr. Demosthenes Chiamardas, held services at 48 North Avenue NE. During the Depression, the First Baptist Church on the corner of First Street and South Avenue SE needed cash. In 1934, St. George was able to purchase its parsonage, which occupied a narrow lot adjoining the church. The site was conveniently near the busy Pennsylvania Railroad station, where many Greeks had established businesses.

St. George was not primarily a neighborhood church. Many parishioners lived in Columbia Heights near the steel mill, but others were scattered throughout the city of Massillon. Some lived in neighboring counties to the west and south. There were strong ties to areas that had once been linked to Massillon by the Ohio and Erie Canal. The Northern Ohio Traction and Light trolley cars followed the old canal routes, maintaining the connection with Dennison in the Tuscarawas River valley to the south and Cleveland to the north.

As the parish grew, St. George needed more room. A decision was made to demolish the house in which services had been held for nearly 20 years and to rebuild on the same site. The dedication of the new church was held on April 26, 1953. St. George has continued to expand by purchasing adjacent property. AHEPA has also continued to play a major role in supporting the parish. The pride of the Massillon Orthodox community in its church is palpable.

Before a parish was established in Massillon, it was common for a priest from Canton to perform a wedding at the home of the bride or groom. In October 1927, Fr. Ioakeim Doulgerakis (second from the left) of Holy Trinity Greek Orthodox Church presided over the wedding of Gust Marinakis and Maria Douka, who had arrived in the United States the previous summer. The photograph includes the bridal party and guests. (Courtesy Judy Mossides.)

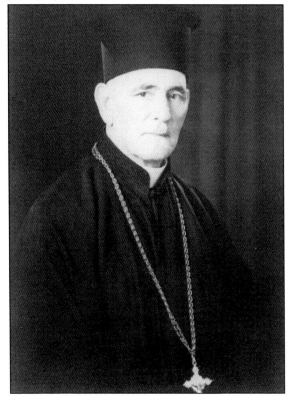

Fr. Demosthenes Chiamardas immigrated to the United States as a barber in 1906. After he was ordained, he served parishes in the Northeast, then was appointed the first priest of St. George Greek Orthodox Church in the spring of 1931. He held services in a rented space downtown. His stay was brief. Many parishes during the Depression had difficulty keeping priests because of the economic conditions. (Courtesy James Chiamardas.)

In 1931, underworld figure William Kirkilis was gunned down outside a coffeehouse in the Columbia Heights section of Massillon. Fr. Demosthenes Chiamardas, assisted by two other priests, conducted the funeral at St. Timothy Episcopal Church, one of the city's oldest and most distinguished institutions. The Massillon Greek community was allowed to use the church for large ceremonies, but the funeral for this notorious figure outraged many Episcopalians. (Courtesy Massillon Museum.)

In 1934, the First Baptist Church at First Street and South Avenue SE needed cash, and St. George needed a home. Though there was a risk, it was a good time to buy. The parsonage (shown at the left) was valued at $9,000, but was sold to St. George for $4,000. When the windows were open, parishioners could hear the hymns from next door. (Courtesy Massillon Museum.)

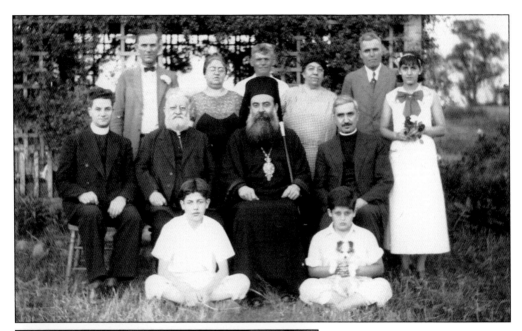

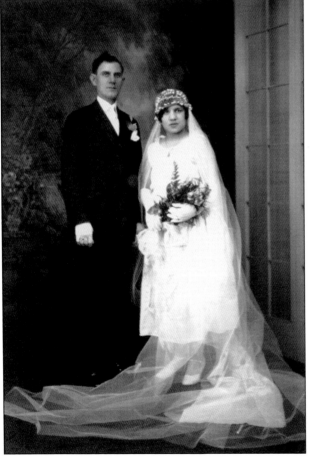

Archbishop Athenagoras visited the three parishes of Stark County in 1935. On June 26, he stopped at the 12-acre Lambrou farm just north of Canton, a popular summer getaway for the community. Seated above are, from left to right, Deacon Nicodemos, Fr. Gregorios Pantazonis of St. Haralambos Greek Orthodox Church, Archbishop Athenagoras, and Fr. John Kapenekas of Akron. The part-time St. George Greek Orthodox Church priest, Fr. George Sikas, is not present. Among the parish leaders standing behind the archbishop are George Panis (on the left), godfather of the church; Peter L. Lambrou (third from the left), owner of the farm and first president; and Nick Orphan (second from the right), the first vice president. In the photograph to the left, Panis is shown with his bride Theone. He owned the Sheridan Restaurant in Massillon and was a major financial supporter of the parish. (Courtesy Dorothy Protos.)

In the first eight years of the parish, many priests had come and gone. It was Fr. Constantine Papademetriou who brought stability to St. George. The photograph at right was taken in 1939 on the day he left Greece. His daughter-in-law, Presbytera Athanasia Papademetriou, writes that on arriving in the United States, he went to receive Archbishop Athenagoras's blessing. The archbishop informed him that priests in the United States did not have beards or dress in traditional style and loaned him $100. Papademetriou shaved his beard (below) and bought a black suit before presenting himself at St. George. He served the community for six years. Later the rules were relaxed, and he was able to grow a mustache again and a goatee. (Right, courtesy Nikki Tweddle; below left, courtesy Rev. Dr. George C. Papademetriou.)

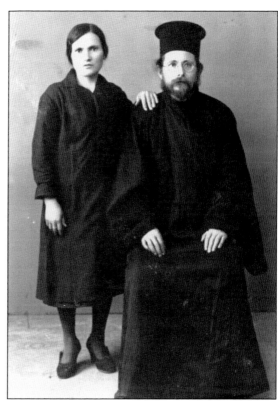

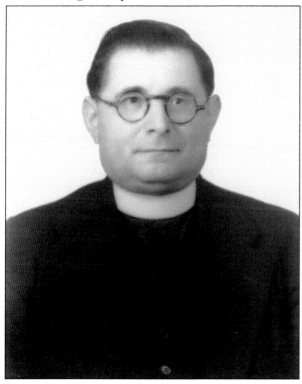

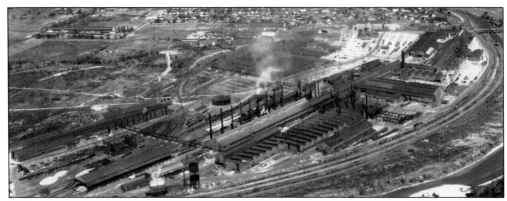

Central Alloy Steel, later Republic Steel, was the primary industry in Massillon. It spawned the development of Columbia Heights, which is partly visible at the top of this photograph. A multiethnic neighborhood, Columbia Heights had a concentration of Greek residences and businesses that catered to mill workers. As with many predominantly male areas, it also developed an unsavory reputation for gambling, bootlegging, and prostitution. (Courtesy Massillon Museum.)

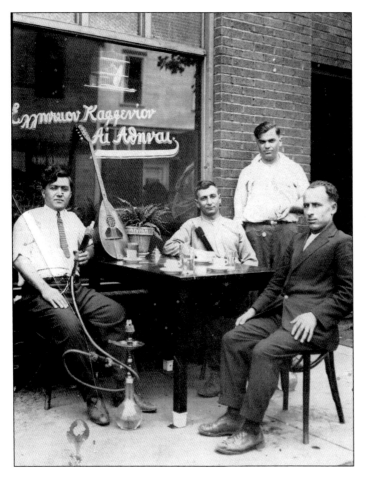

After work, men would congregate at coffeehouses to drink, play cards, read newspapers, and listen to music. As they had in Asia Minor, they also smoked a water pipe. The Athens Greek Coffee House in Columbia Heights was operated by John Letjekides (standing). There were three other coffeehouses on this street. Some were notorious for gambling; others like this one tried to stay within the law. (Courtesy Bessie Samuels.)

Harry Corosides was a native of Ordou. After he joined his brother John in Massillon in 1914, he never saw his wife Sophia again. In 1922, she fell victim to ethnic cleansing in Asia Minor. Harry never remarried. He lived in Columbia Heights and owned a coffeehouse, although he is best known as a barber. He served as cantor of the church and as an AHEPA officer. (Courtesy Thamy Greenbaum.)

Eftherbe (left) was the wife of coffeehouse owner John Letjekides. Parthena was married to George Elias, who also owned a coffeehouse in Columbia Heights. Before moving into their own six-bedroom home, the Eliases lived upstairs at the Letjekides house and baptized their friends' premature twins, who died shortly after birth. The women were keen shoppers who watched for sales so they could dress well. (Courtesy Bessie Samuels.)

George and Helen Mossides lived in a large house on Bebb Avenue, running a bar and restaurant downstairs and a rooming house for bachelors upstairs. The funeral of their daughter Toula in 1931 may have been the first funeral at St. George Greek Orthodox Church. In 1942, George Mossides died at age 48, and his wife supported their three children by keeping up the family businesses. (Courtesy Judy Mossides.)

Harry Mossides, George's younger brother, and Dorothea Janidou were married by Fr. Chrysostomos Lavriotes at St. Haralambos Greek Orthodox Church on August 28, 1921. Dorothea had arrived in the United States just weeks before. Although both were natives of Pontos, and international politics were roiling the Greek community, they did not hold the ceremony at the Canton "Pontian parish." Later Harry would move the family to California. (Courtesy Bessie Samuels.)

George and Alexandra Orphan lived in Columbia Heights. This photograph of their oldest children—Gust, Harry, and Annie—was taken about 1926. George and his brother Nick were partners in a grocery until George opened his own shop. In 1938, with the help of his son Gust, he built the Twin Bar Grill next to fellow parishioner Peter Scufalos's Boston Lunch on Tremont Avenue. (Courtesy Annie Muratides.)

Nick Orphan and wife Sophia, both natives of Ordou, were married in Toledo in 1924 and had seven children. From 1917 to 1959, seven days a week, Nick ran a busy grocery store in Columbia Heights with *N. Orphan* engraved in stone on the facade. He and his family, however, lived across the river in more genteel surroundings. He was the first vice president of the parish. (Courtesy Sophia Orphan.)

Christos Vattos was naturalized in May 1926 and immediately set out for Greece. He had heard of a lovely single woman named Catherine living in Kalamata. Before meeting her, he lingered outside her home and apparently liked what he saw. They were married on August 22, 1926, and soon headed back to Massillon and their home at 123 Lane Court SW. (Courtesy Beth Gatsios.)

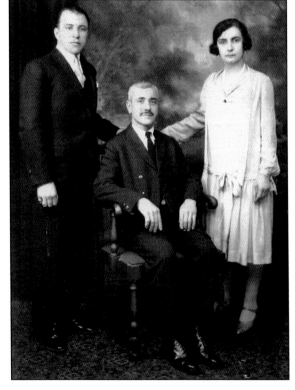

Christos and Catherine Vattos lived in a house belonging to Christos's uncle Panayiotis Paleologou (seated), who had brought him to this country. When Paleologou returned to Greece, he sold them the house. Vattos worked as a shearman in the steel mills, then became a partner with Nick Orphan. Vattos, who had planned to stay for only four years, spent the remaining 70 years of his long life in Massillon. (Courtesy Beth Gatsios.)

Tony Paris (Antonios Perris) arrived in America from his native Chios in 1917. On October 16, 1921, he and Calliope Zampelas were married by the mayor of Massillon. Tony is shown here with their first two sons, Papos (left) and Thomas. In 1925, Calliope gave birth to twin boys and died the next day. Tony suddenly found himself a single parent with four young sons. (Courtesy Alexander Paris.)

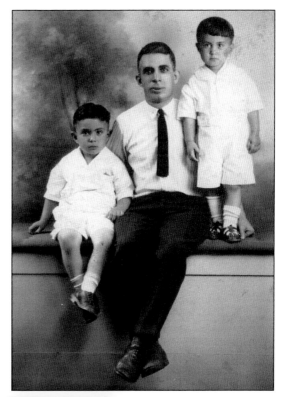

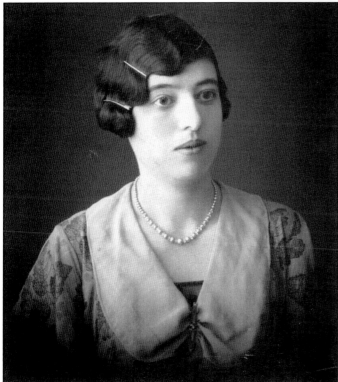

While the widower Tony Paris earned his livelihood at the aluminum factory next to Republic Steel, his childless older sister raised one of the twins. His mother raised the other three boys. In 1933, Tony returned to Chios to marry. This photograph of Despina was taken there about the time of their marriage. She raised his sons, and they had two sons themselves. (Courtesy Alexander Paris.)

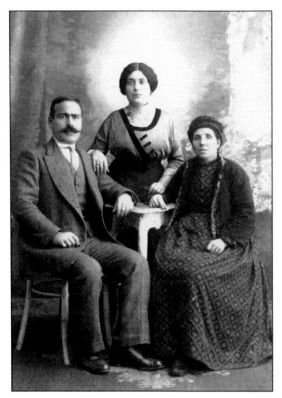

Demetrios Dolmas and his fiancée Maria Paloglou are shown here with Maria's mother, Smaragda, in Constantinople on the eve of Demetrios's journey to America. Seven years later, in 1920, Maria sailed to meet him in New York, where they were married. Their four children were born in Massillon. The Dolmas family traveled thousands of miles from cosmopolitan Constantinople to a small midwestern steel town. The cultural distance was even greater. Son George (below) played football at Washington High School for the immortal Paul Brown. He stood six feet tall and played tackle on the undefeated 1940 team that outscored its 10 opponents 477-6. Many consider it to be the greatest high school football team ever. Still, his parents were not enthusiastic about him taking part in this dangerous American game. (Courtesy Marie Lekorenos.)

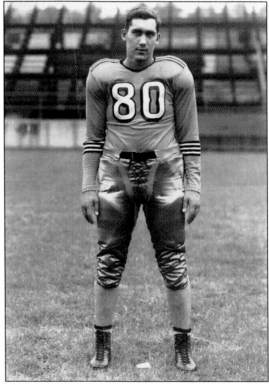

The road to Massillon was not easy for Cleoniki Paloglou. This battered photograph was taken around 1925, when she was betrothed to Massillon resident Peter Spanos. In July 1926, he boarded a train for New York on his way to Greece for the wedding. He never arrived. He died in a train wreck in the Pennsylvania mountains. His funeral was held on June 21 at St. Timothy Episcopal Church, with Bishop Philaretos of Chicago officiating. The next year, suitor Manolis Janikis successfully made the trip. He had served in the army as part of the American Expeditionary Force in Europe and earned his citizenship. On February 13, 1927, he and Celoniki were married in Piraeus, Greece. They soon sailed for the United States, where Celoniki was reunited with her sister Maria Dolmas, who was living in Massillon. (Courtesy John Janikis.)

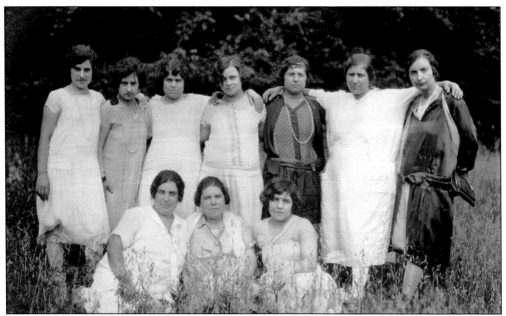

Massillon was a small city surrounded by private farms and public parks, which became accessible as cars became more common. Picnics and outings in the country were an inexpensive form of summer recreation. In the days before air-conditioning, they provided a welcome relief from the heat, noise, and congestion of the city. These women are enjoying a rare moment away from the demands of their families. (Courtesy Dorothy Protos.)

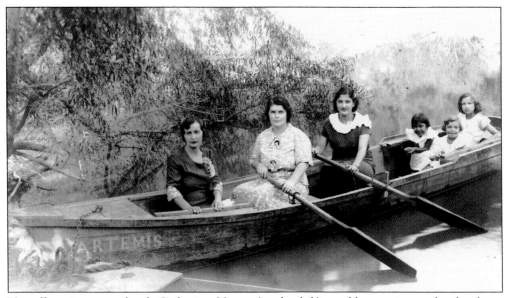

Not all outings were local. Catherine Vattos (at the left) would sometimes take daughters Athena and Beth (second and third from the right) to visit a cousin who lived a few hours away, along the Ohio River in West Virginia. While the *Artemis* is still moored to the dock, the well-dressed rowers pose with their oars in the water, and the Vattos girls lean forward in anticipation. (Courtesy Beth Gatsios.)

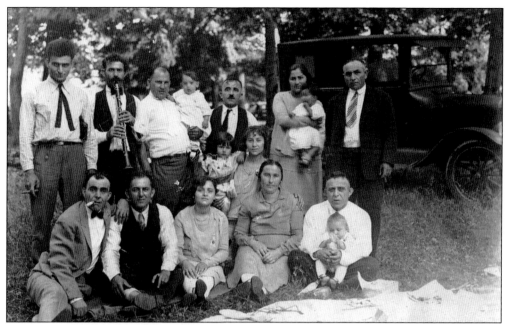

In 1930, George Elias (standing third from the left) is holding his son Louis, whose baptism is the cause for celebration. Beside him stands Louis's godfather, George Kalenterides. A bachelor who roomed with the Elias family, Kalenterides played the clarinet and bagpipe and was also a skilled hunter who shot rabbits for the family to eat. Parthena Elias (kneeling) holds Louis's sister Bessie. (Courtesy Bessie Samuels.)

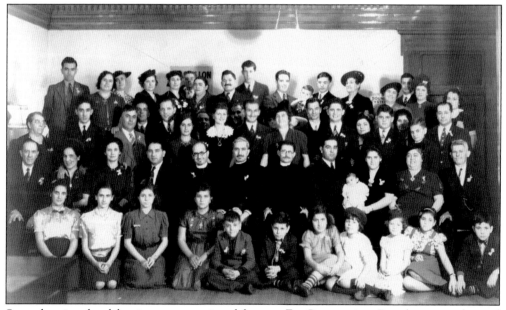

Some baptismal celebrations were quite elaborate. Fr. Constantine Papademetriou (second row, fifth from the left) baptized George Marinakis on October 23, 1939. Godmother Marcella Angelas (second row, third from the right) is sitting next to the father, Alexander Marinakis, and holding the baby. The party includes three priests and nearly 50 other guests. (Courtesy Tina Cotopolis.)

Since the train was the main means of transportation, most immigrants first set foot in Massillon when they disembarked at the Pennsylvania Railroad station. A number of savvy Greeks operated businesses near this hub of activity. On Penn Avenue, James Copanos ran Jimmy's Candy Shop, and Steve Nosis had the Park Way Grille. The Rizos family also owned a steakhouse. (Courtesy Massillon Museum.)

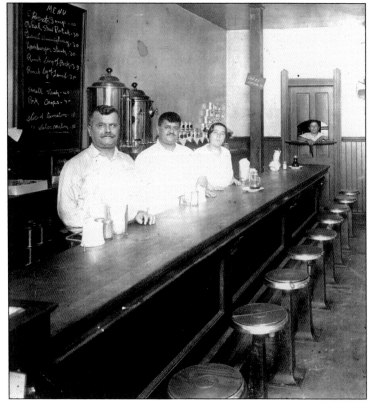

The Liossis brothers worked as laborers until they saved enough money to open their own business. Shown from left to right, Nick and Peter Liossis and their wives, both named Mary, operated this restaurant on the ground floor of the Hotel Vendome across from the station. Among the items on the menu are roast leg of lamb and roast loin of pork, each costing 35¢. (Courtesy Goldie Liossis.)

Mary and Peter Liossis were married in their native Kranidion in 1927. This photograph was taken in late 1928 in Massillon, after the birth of their son Chris. Mary's brother Andy Poulos (standing) worked as a cook and was the baby's godfather. In late summer, neighborhood children would gather at the Liossis home to eat cherries off the tree in the backyard. (Courtesy Goldie Liossis.)

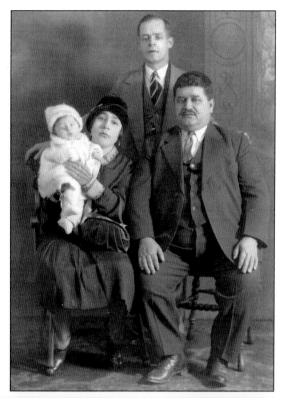

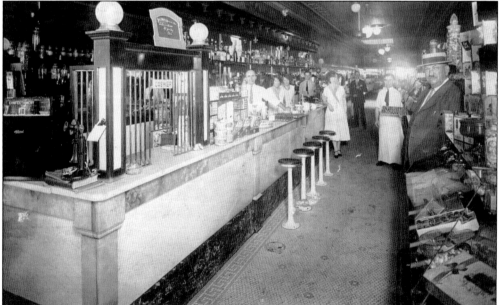

Christ Vlachos, one of the first Greeks of Stark County, established the Sugar Bowl in 1905. For much of its long history, this confectionery was operated by Peter George (on the left behind the counter) and his family. At the back, there was a seating area where three generations of Massillonians enjoyed hot fudge sundaes after Friday-night football games and on Saturday-night dates. (Courtesy Joanne Goumas.)

James Heliotes (seated in the middle) brought his cousin Peter George (seated at the left) to the United States to work for him. In 1915, they became partners in the Sugar Bowl, and George moved from Fort Wayne, Indiana, to Massillon to run the operation. Their cousins, the Linardos brothers, ran a confectionery in Canton. Heliotes would later expand into owning theaters as well. (Courtesy Joanne Goumas.)

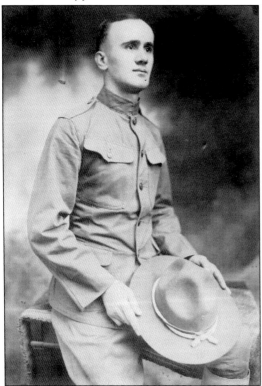

In World War I, Peter George served in the United States Army in France as a cook. During this time, the Sugar Bowl was remodeled, with candy production moving from the back of the store to the second floor. He was discharged in 1919 and returned to Greece to wed Marian (Marianthe) Angeklis, whom he brought to Massillon in 1921. He became sole owner of the Sugar Bowl around 1931. (Courtesy Joanne Goumas.)

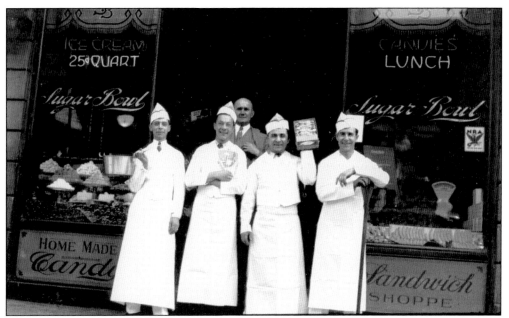

Owner Peter George stands behind some Greek staff members outside the Sugar Bowl at 45 Lincoln Way East. The first floor was the retail area. On the second floor, candy was made "from pure ingredients and with the greatest cleanliness." The third floor served as a dormitory for the male staff, most of whom were Greek. Many would later set up their own confectioneries. (Courtesy Rudy Turkal and Tom Persell.)

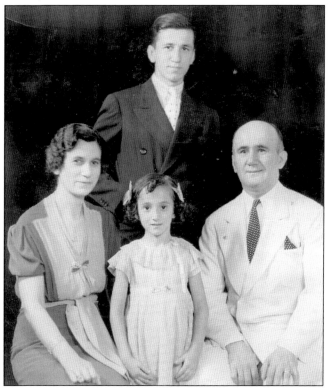

Peter and Marian George were always busy. He handled purchasing and ran the retail business. She oversaw the candy production, and children James and Joanne helped out. At Easter, they produced 10,000 pounds of chocolate. At Christmas, they twisted thousands of candy canes and made a dozen varieties of peanut brittle. The shop also produced 25 different kinds of jelly beans. (Courtesy Joanne Goumas.)

Around 1910, a three-block stretch of Tuscarawas Street in Dover was renamed Factory Street. It was lined with restaurants, bars, billiards parlors, barbershops, and rooming houses that catered to factory workers, including many Greeks. Northern Ohio Traction and Light operated trolley cars down the middle of Factory Street, connecting Dover and New Philadelphia to Massillon and Canton, later extending from Uhrichsville and Dennison to Akron and Cleveland. (Courtesy Tuscarawas County Historical Society.)

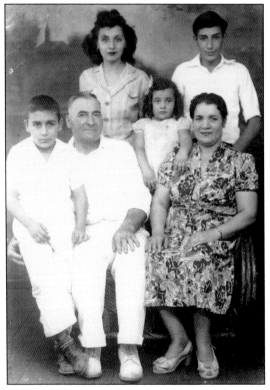

George Lekorenos lived on Factory Street and worked at Reeves Steel and Manufacturing, the largest employer in the county. He was a veteran of World War I who returned to Samos in 1926 to marry. George and Stavria are shown at Meyers Lake Park with their children around 1943. Although they had no money for rides, they often met friends at this popular amusement park outside Canton. (Courtesy Mary Glaros.)

In 1937, Deena Kyriakis (left) and her friends Stella (center) and Henrietta Betsacos are in native costume. Each holds a rolled piece of paper, as if smoking. Actually, none of them smoked, and Deena actively disapproved, but the photographer thought the fake cigarettes made them look up to date. Deena, her husband Angelo who worked as a barber, and their two children lived near Factory Street in Dover. (Courtesy Frances Koroni.)

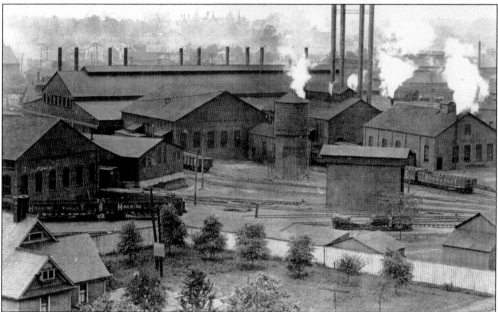

At its peak in the 1920s, American Sheet Steel and Tin Plate of Dover employed as many as 800 workers, including many Greeks. It produced materials that were sent to mills like Reeves Steel and Manufacturing across the street, where the metal was galvanized and shaped into products including tin cans, gutters, and—a Reeves specialty—stovepipes. The company went out of business during the Depression. (Courtesy Tuscarawas County Historical Society.)

Before the development of concrete and plastic pipe, clay pipe was the standard. The little town of Uhrichsville was the clay pipe center of the nation, with a number of factories clustered around the rich clay deposits. This is the Robinson-Graves Sewer Pipe factory in 1901. Many Greeks worked in these factories before finding better-paying jobs in the larger cities of Canton and Massillon. (Courtesy Tuscarawas County Historical Society.)

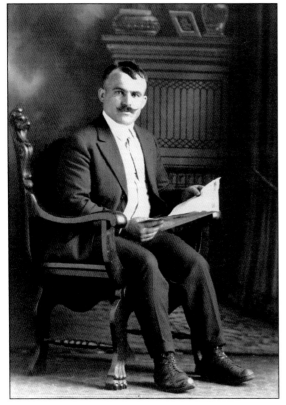

Stylianos Karapanagiotides worked at the Universal Sewer Pipe Company. He had left his young wife and six-month-old daughter in Ordou and arrived in Canton in 1913. He soon found that he preferred small-town Uhrichsville, which reminded him more of the home he left behind in Asia Minor. His Greek name was too much for the local bank to handle, so he changed it to Steve John. (Courtesy Mary Steve.)

Steve John's wife died, but their infant daughter survived. By 1925, 13-year-old Morphe was living with relatives in Greece. Steve remarried, bringing his new family to Uhrichsville. Shown here, Morphe and Harry Xenos soon eloped. After two years, they returned to Uhrichsville, and Harry was arrested for absconding with a minor. After Harry spent a night in jail, the couple enjoyed 56 more years together. (Courtesy George and Annie Muratides.)

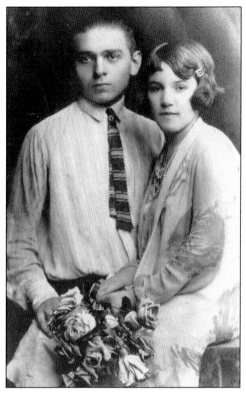

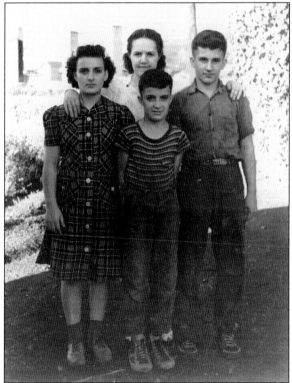

Standing from left to right are Steve John's children Mary, Andy, and John. Morphe stands in back. Steve and his second wife, Sophia, raised the family in a small apartment block on the grounds of the Universal Sewer Pipe factory. The smokestacks are visible in the background. The children roller-skated on dirt roads, smoothed and compacted by trucks laden with finished pipe. (Photograph by Bill Davis, courtesy Mary Steve.)

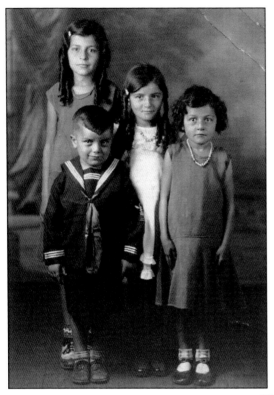

The Uhrichsville Greek community included—at times—Pete and Despina Kotanides. Pete worked both in the steel mills of Canton and in the clay pipe factories of Uhrichsville. Their oldest daughter, Sophia, was born in Canton, Maroula in Uhrichsville, Parthena in Canton, John in Uhrichsville, and Elbus (not pictured) in Canton. Sophia was baptized by Steve Terakedis (below). He married Anna Mary Downing, and they raised 12 children in Uhrichsville. Pete also had relatives nearby. Pete Xenos, along with his wife Maria and brother Harry, were survivors of the death march in Asia Minor. Their older brother had immigrated in 1913 and had been able to bring them to the United States. After having lost everything, Uhrichsville was a haven where they could live and work in safety and enjoy the company of cousins. (Courtesy Kotanides family.)

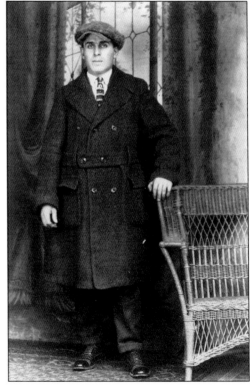

Anna (Erasmia) Vamvakidou was another survivor of ethnic cleansing. She escaped on a Russian ship and lived in Russia for three years before being reunited with family in Thessaloniki, Greece. She came to Uhrichsville to marry Gus Morris (Konstantinos Marvrimidis). He originally worked in the sewer pipe factories, then set himself up as a tailor in Uhrichsville and later in Massillon. (Courtesy Kotanides family.)

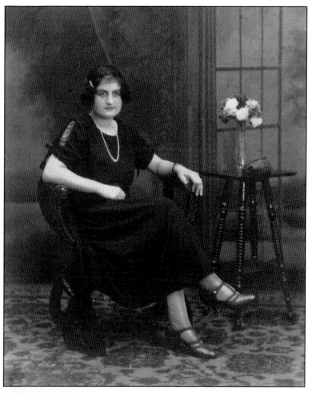

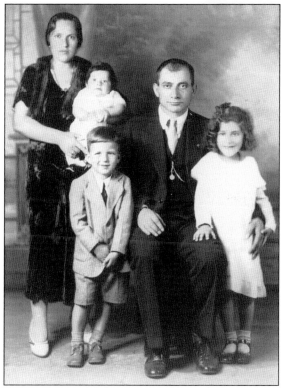

Ahilleas Zantopulos was employed at the Timken Roller Bearing Company, then moved to Uhrichsville. He worked at the Universal Sewer Pipe Company, living on the grounds. After becoming a citizen, he returned to Greece in 1927 to marry Liza Michailides. She enjoyed rural Uhrichsville because it reminded her of home. Their daughter Ferna was born there, but by 1930, the family was living in Canton, where son John was born. (Courtesy Harry Zantopulos.)

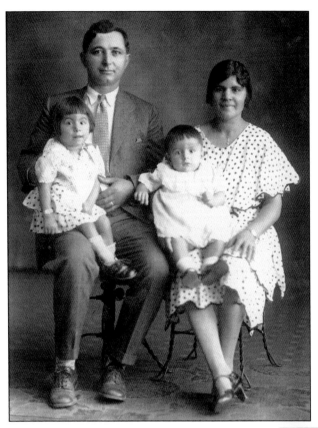

James Demis arrived in Cincinnati in 1910, two years before his brother Louis. After working on the railroad, they came to Massillon in 1916 to work in the mills. In 1920, they opened Demis Brothers Grocery at 1271 Thirteenth Street SE, with James as the full-time grocer. Louis was hired as a crane operator at Central Alloy and helped after hours at the store. James and his wife Diamando, who were married in 1926, are pictured with their two oldest children. In 1934, as shown below, 40-year-old Louis returned to Greece to marry Chrysanthe. The two families had nine children, and it became increasingly difficult to support them all on the profits from one grocery. In 1942, James purchased Jim's Grill in Uhrichsville, while Louis and Chrysanthe continued to run the grocery. (Courtesy John Janikis.)

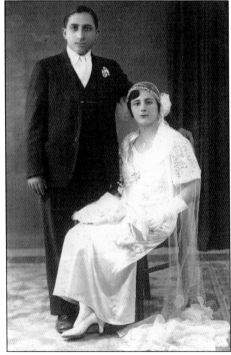

Kyriakos Chantes arrived in the United States in 1904 and worked at jobs all around the country. After becoming a citizen, he returned to Samos, where he married Maria in 1929. By 1934, they had moved to Massillon. In 1949, Kyriakos suffered a heart attack at Republic Steel and died. Maria and daughters Virginia and Pat lived in a house they purchased from Fr. Dorotheos Neamonitas. (Courtesy Pat Chantes.)

Nicholas Stavrakis was born in Massillon in 1930. He attended Holy Cross Seminary, where this photograph was taken. At about the same time, his father Theodore died of a heart attack at Republic Steel. Stavrakis was the first Stark County native to be ordained a priest. He served Holy Trinity Greek Orthodox Church from 1953 to 1957 and was an interim priest at St. George Greek Orthodox Church in 1957. (Courtesy Stacia Amentas.)

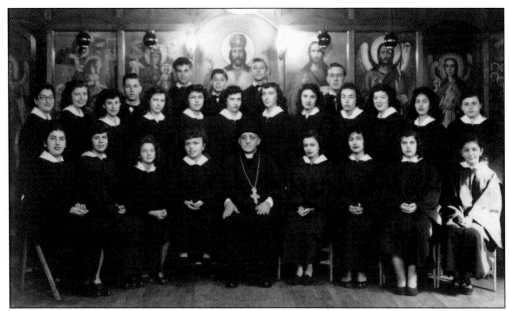

The St. George Greek Orthodox Church choir is seen here with Fr. Dorotheos Neamonitos in 1947. Before the formal organization of the choir, girls would sit opposite the cantor and sing as directed by the priest. The choir was started in the 1940s with a Professor Holt as the director. The Kokinos family donated a pump organ they had played at home. Early organists included Nicholas Stavrakis and Barbara and Dena Demis. (Courtesy Margaret Gibson.)

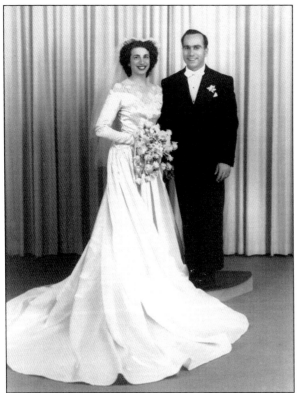

On November 14, 1948, Fr. Dorotheos Neamonitos of St. George and Fr. Vasilios Hartofilax of Holy Trinity Greek Orthodox Church officiated at the wedding of Annie Orphan and George Muratides. The ceremony was held at St. Timothy Episcopal Church, where large events had always been held for St. George parishioners. Since the inception of the parish, there had been talk of needing a larger church. (Courtesy George and Annie Muratides.)

Fr. Dorotheos Neamonitos was a single priest from Chios who served St. George from 1933 to 1934 and from 1945 to 1950, when this photograph was taken. He was a kindly man who delighted small children by giving them a dime if they could recite the Lord's Prayer in Greek. During his second tenure, the parish decided to build a new church, and the cornerstone was laid. (Courtesy Pat Chantes.)

Fr. Dorotheos Neamonitos observes confectioner Peter George passing a check to restaurateur Peter Scufalos. These two businessmen and grocer Nick Orphan spearheaded the drive for a new church. The house purchased in 1934 could no longer accommodate a parish with over 100 families from Stark, Tuscarawas, Wayne, and Coshocton Counties. In 1950, the parish voted unanimously to build a new church on the same site. (Courtesy Joanne Goumas.)

By St. George Greek Orthodox Church's name day on April 26, 1953, a new brick structure had been built for $75,000, and the parish was free of debt. The priest at this time was Fr. Ioakeim Doulgerakis. He would retire in 1957 and return to Greece after 34 years in America. Since then, the parish has purchased the adjoining properties, but this structure still serves as the place of worship. (Courtesy Beth Gatsios.)

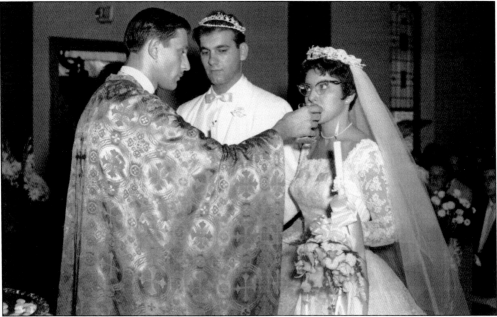

On September 1, 1957, Fr. Nicholas Stavrakis officiated at the wedding of Beth Vattos and James Gatsios. The bride and the priest had attended school together, and Presbytera Peggy Stavrakis served as *koumbara*. The church was packed. Movie cameras overloaded the circuits, and—dramatically—the fuses blew. The organist was unable to play, and the choir sang a cappella as the bride walked down the aisle. (Courtesy Beth Gatsios.)

Four

THE AMERICAN HELLENIC EDUCATIONAL AND PROGRESSIVE ASSOCIATION

AHEPA was established in Atlanta, Georgia, to combat bigotry and the rising influence of the Ku Klux Klan. AHEPA came to Stark County in 1925 after an enthusiastic new member, a traveling salesman from Yonkers, New York, encountered the bustling Canton Greek community. Longfellow Chapter 59 was established and soon became one of the most active chapters in the nation. Its heyday, however, was short. Just as Holy Trinity Greek Orthodox Church split off from St. Haralambos Greek Orthodox Church within five years, Andrew Nickas Chapter 289 split off from Longfellow Chapter 59 within eight years.

The AHEPA family, however, continued to grow. In 1929, the William McKinley Chapter of the Sons of Pericles youth auxiliary was established. In 1935, the Daughters of Penelope became the official women's auxiliary, and Chloris Chapter 40 was soon established in Canton. The Victoria Chapter of the Maids of Athena youth auxiliary followed in 1941. Finally, in 1947, the Longfellow and Nickas AHEPA chapters reunited to form Canton Chapter 59. In a community prone to argument and schism, these organizations allowed members from different backgrounds and with different political and religious affiliations to meet on common ground.

The history of the AHEPA family is intertwined with the development of other Greek organizations. Except for the societies that developed in the churches, most of the local organizations grew out of the immediate needs of the community and were short-lived. For a time, societies based on place of origin thrived, offering assistance to members in need. This was essential at a time when neither the government nor the private sector provided a social safety net. Only the strongest of these organizations endured after the mutual-aid function faded.

In the 1920s, national organizations like AHEPA emerged. The Greek American Progressive Association (GAPA) was a strong rival. These groups encouraged education and American citizenship along with an understanding of Greek language and culture. AHEPA has survived and grown because it has reinvented itself to meet the changing needs of the Greek American community.

In 1917, men from Kosma, Greece, who had come to Massillon, posed for this photograph. Once a villager found employment abroad, he was often followed by family and friends, forming the links in a chain of migration to a new place, where they could live and work together. For immigrants who spoke little English, people who shared a common language, history, and food made all the difference. (Courtesy Joanne Goumas.)

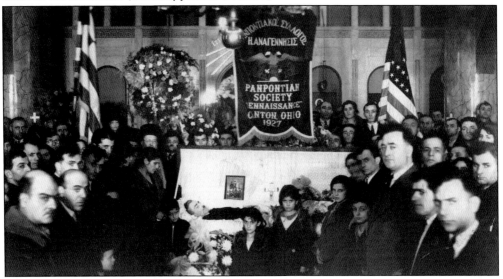

The Pan-Pontian Society Renaissance, established in 1927, was a mutual-aid organization. When a member died, the society helped with funeral expenses and assisted the family. John Lazarides, once a prominent grocer who served as treasurer of Holy Trinity Greek Orthodox Church, died in 1934. The society banner was prominently displayed at his funeral. This group continued on, even after Social Security, insurance, and pensions became available. (Courtesy Georgia Pavlis.)

In 1925, AHEPA supreme president V. I. Chebithes (first row, center), made his first trip from Washington, D.C., to Ohio to install the officers and board members of the newly formed Longfellow Chapter 59. The charter members included prominent Greek businessmen in Stark County. Many were early arrivals from the Peloponnese who were parishioners of St. Haralambos Greek Orthodox Church. Not all were Greeks; one was the executive secretary of the northeast branch of the YMCA, which was located near Holy Trinity and was active in the community. AHEPA members were required to have at least started the process toward becoming a United States citizen. Many charter members had received citizenship as veterans of World War I. For example, Harry Trifelos (shown on the right), served in the army with the American Expeditionary Force in Europe in 1918 and 1919. (Courtesy Mary Trifelos.)

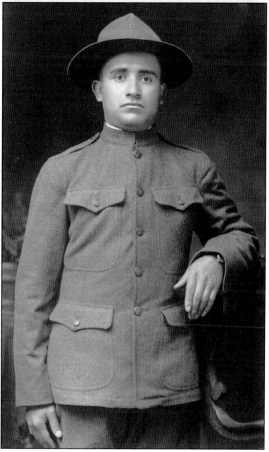

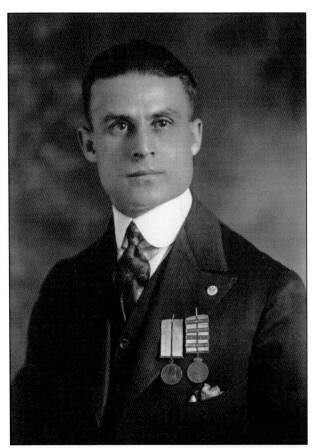

In the early years, AHEPA members, known as Ahepans, were often self-employed businessmen who were able to speak English and had become United States citizens. One of the most active, enthusiastic members of the Longfellow Chapter was Michael Vianos, who followed his brothers to Canton in 1915. A signer of the chapter charter, early officer, longtime member of the board of governors, and strong Cretan partisan, he was also the proprietor of Vianos No. 2 (below), located at 216 Market Avenue South next to the Valentine Theater. His confectionery did excellent business with moviegoers. For Mother's Day in 1922, an advertisement for the Vianos stores made this tempting offer: "With every 2 lb. box of candy bought Saturday we will give a very nice steel pocket pen knife." The store also advertised itself as an ice-cream parlor and served light lunches. (Courtesy Irene Vianos.)

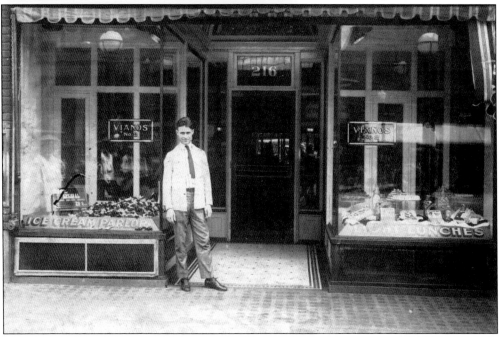

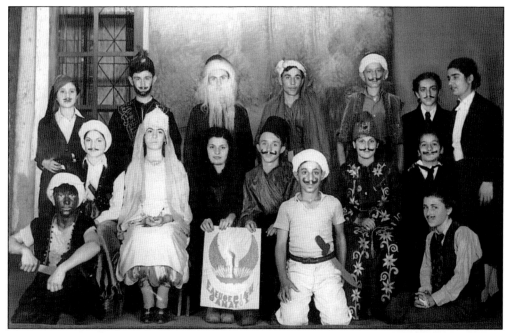

The first philanthropic donation by the Longfellow Chapter was to Holy Trinity Greek Orthodox Church in 1925 "for the education of the Greek children," which included teaching Greek language and culture. This play was held in Koraes Hall around 1938 as part of the annual celebration on March 25 of Greek Independence Day. The sign proclaims, "Freedom or death!" The teacher, Haritine Christu, stands at the right. (Courtesy Flora Anderson.)

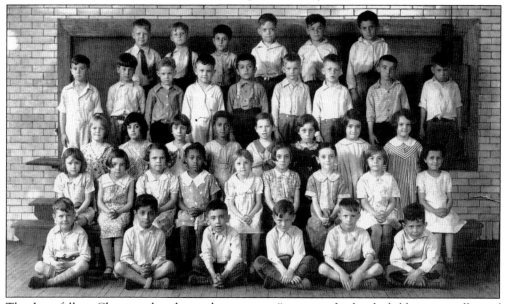

The Longfellow Chapter also donated money to "parents of school children, regardless of nationality, for the purchase of needed clothing, so that they may not be compelled to remain out of school." By the late 1920s, at J. J. Burns Elementary School, students of 26 nationalities made up over 60 percent of the enrollment. This photograph of a first-grade class around 1932 includes 16 Greek children. (Courtesy William Beftoulides.)

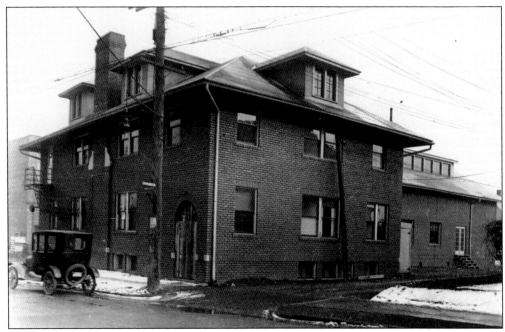

The northeast branch of the YMCA was established in 1922 as one of three branches serving Canton. It provided educational, social, and medical assistance to accelerate the Americanization of immigrants living near factories in the northeast end. In 1925, the Longfellow Chapter sponsored a well-attended public lecture series at the YMCA that raised money for support of Asia Minor refugees in Greece. (Courtesy YMCA.)

In the early years of AHEPA, one of the largest outlays was for funeral wreaths. Ahepan George Laggeris, shown here with wife Eleni and son Harry, was the third Longfellow Chapter member to die. He became ill, received treatment out West, and died there in 1926 at the age of 42. His funeral was held in Canton, and the chapter spent $25 for his wreath. (Courtesy Harry Laggeris.)

At first, women were not official members of AHEPA, but they were active in AHEPA activities. At the Grand Theater on June 12, 1926, Sultana Papachristou was the leading lady in *Hearts That Break*, a play about a Greek immigrant member of AHEPA. It was written by Angel Alex, a Canton poet and restaurateur, and performed by AHEPA chapters across the country. (Courtesy Sophia Klide.)

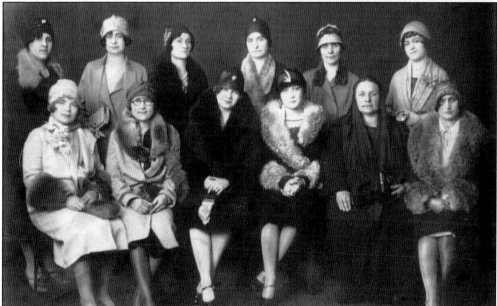

In April 1928, a catastrophic earthquake struck Corinth, Greece. The Longfellow Chapter held a benefit for the survivors, raising over $1,300. These women organized a bazaar, donating handmade shawls, linens, and scarves. Many of them played an important role behind the scenes in the early success of AHEPA and were among the early leaders of the women's auxiliary that was organized in the 1930s. (Courtesy Sophia Klide.)

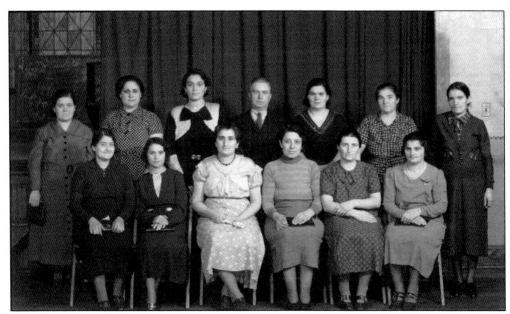

One of the missions of AHEPA was the naturalization of Greek immigrants. Language was a major obstacle especially for women, and fewer became citizens. Unlike their husbands, many wives rarely left the neighborhood and seldom needed to speak English. Classes were held to prepare the immigrants, many with little or no formal schooling, for the frightening ordeal of applying for citizenship. Men often studied English after work at the local high school. Later, classes were taught at the churches. The English class at Holy Trinity Greek Orthodox Church (above) met in Koraes Hall. The English class at St. Haralambos Greek Orthodox Church (below) was taught by a Miss Klein (second row, on the right). She is drilling them in basic English sentences: "My name is ———," "I live at ———," and "I was born in ———." (Above, courtesy Ann Manos; below, courtesy Evelyn Eustathios.)

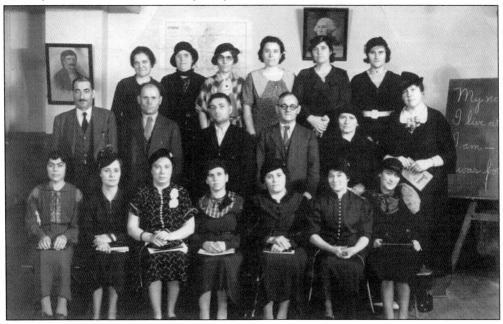

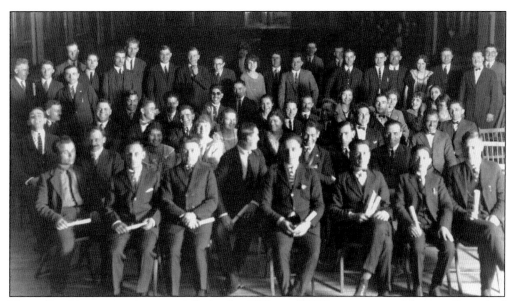

Naturalization ceremonies, especially in the 1920s and 1930s, were very elaborate. Organized by groups including the chamber of commerce, Daughters of the American Revolution, and American Legion, they were held with great pomp in the most impressive public spaces in the city. The new American citizens were presented with a certificate of citizenship and treated to speeches by local clergy, judges, and other dignitaries. (Courtesy Judy Mossides.)

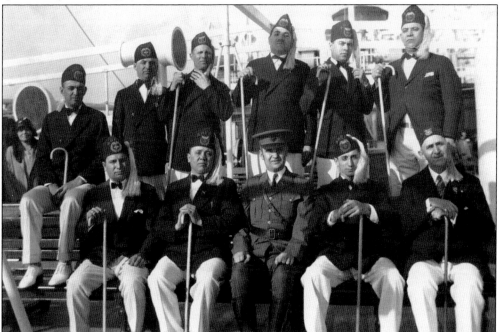

Ahepans bound for Greece in 1929 pose on the promenade deck. In the early years, AHEPA sponsored an annual Easter excursion to Greece. Members were able to travel at a discount, and the trips promoted the fledgling international tourist trade. About 500 Ahepans and their families took part in the first excursion, setting out from New York on March 19, 1928, aboard the SS *Sinaia*. (Courtesy Joanna Palacas.)

The Canton chapter of AHEPA played a leading role in the establishment of local chapters in Massillon, Akron, and Warren and also in cities as far away as Buffalo, New York. In 1926, George J. Pinis became the first president of Massillon Philanthropos Chapter 74. He originally had come to Massillon to operate the newsstand inside the city bus terminal, shown here beside Stark Dry Goods. (Courtesy Massillon Museum.)

Robert Peet Skinner was born in Massillon and had been editor of the Massillon newspaper, the *Evening Independent*. He joined the diplomatic service and was appointed ambassador to Greece. The Philanthropos Chapter helped host a banquet in his honor at the Elks Club ballroom on May 24, 1929. The event was attended by Ahepans from northeastern Ohio and the supreme vice president from Buffalo, New York. (Courtesy Massillon Museum.)

Anthony Paris was an Ahepan at a time when members went to considerable expense to obtain the proper uniform. Fezzes were a prized possession and not cheap. They were made by only a few manufacturers, and there was a waiting list. As an indication of their value, the Canton chapter listed its assets in January 1927 as $38 in the bank and 38 unsold fezzes. (Courtesy Alexander Paris.)

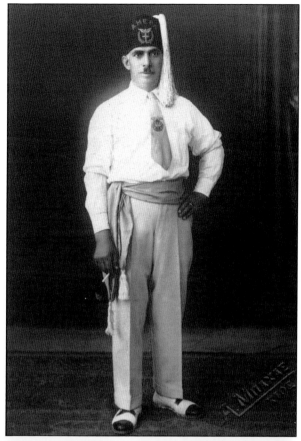

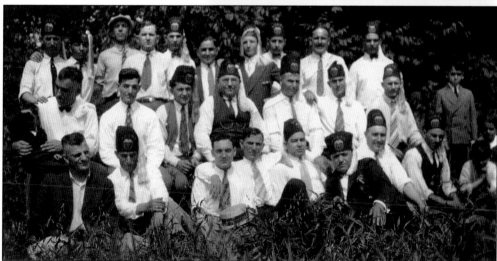

Massillon AHEPA members proudly demonstrate their status with jaunty fezzes. AHEPA held annual picnics at area lakes and parks. Few had cars, so buses were provided. The picnics were lively affairs that attracted people from all over northeastern Ohio. In 1927, a picnic at Brookfield Lake near Massillon featured a 200-yard run between Canton and Akron women and a tug-of-war between single and married Ahepans. (Courtesy Beth Gatsios.)

GAPA started in Pittsburgh and established itself in Stark County before AHEPA. Archimedes Lodge 8 was organized on Christmas Day 1922, with headquarters in the Carnahan neighborhood near Holy Trinity Greek Orthodox Church. Before the formation of the Andrew Nickas Chapter of AHEPA in 1933, few Holy Trinity parishioners joined; instead they were drawn to GAPA. Elizabeth and Nicholas Spondyl are shown in their GAPA finery. Both organizations promoted American ideals and citizenship, although with a different emphasis on the development of English language skills and on the role of the Greek Orthodox Church. GAPA was especially effective in organizing young people at a time when there was no comparable organization either in AHEPA or in the church. The GAPA youth auxiliary orchestra Prometheus (below) was extremely popular. (Left, courtesy Virginia Gotides; below, courtesy Andrew Andreadis.)

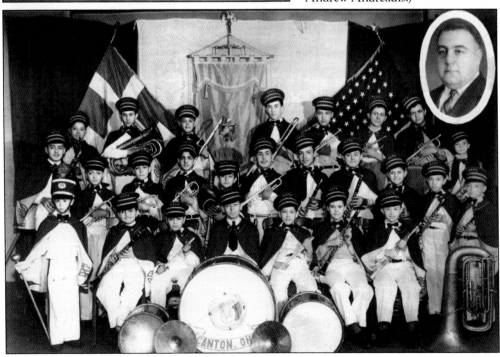

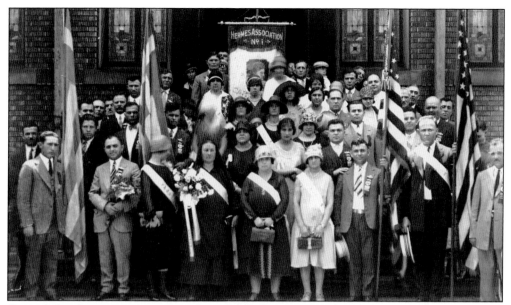

One of the first societies organized in Stark County was the Hermes Association. It was established by immigrants from Pyrgos, in the Eleia area of Greece. The No. 1 on the banner shows that the Canton chapter of this mutual-aid society was the first. Members proudly stand before St. Haralambos Greek Orthodox Church, where most were parishioners, displaying both Greek and American flags. (Courtesy George Macrides.)

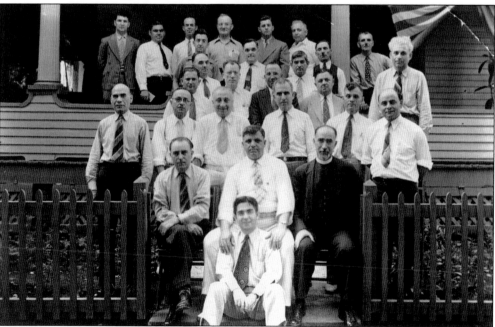

This photograph was taken around 1940 for a Pan-Eleian district convention in Canton. Fr. John Petropoulos of St. Haralambos sits on the right in the second row. By this time, the mutual-aid societies had passed their peak. Although pride in the homeland remained high, bonds between immigrants from the same area were weakening, and the American-born generation was finding other outlets. These organizations ultimately evolved or disbanded. (Courtesy Steve Chrisanthus.)

Philip Anastas (Anastasiades) served as an officer in both AHEPA and GAPA. A native of Constantinople, he was a college graduate who spoke eight languages. He is shown in 1916 displaying his physique in Constanza, Romania, on the Black Sea. He and his wife Mary arrived in the United States in 1920 and by 1926 had become citizens. Anastas was hired by the Dime Savings Bank and within months was promoted to manager (below) of the travel and foreign currency department. He and Andrew Nickas were the only Greeks who were active in organizations outside the Greek community. Anastas gave speeches to groups throughout the city, Greek and non-Greek alike, often about the importance of education. Because of his linguistic ability, he was seen as a spokesman for the entire foreign community. (Courtesy Michael Anastas.)

Mary (Marika) Davides was born in the Pontos region of Asia Minor. Her family moved to Russia, where it introduced tobacco cultivation to the area. In 1920, during the Bolshevik Revolution, Mary and her husband Philip Anastas fled Russia. Settling in Canton, she became active in women's organizations. She served as treasurer of the St. John's Society, a group established in 1925 with a mission "to protect rights of Greek women in Canton." In 1935, she was the president of both the Koraes Ladies Society of Holy Trinity Greek Orthodox Church and the Spartan Women's Club, "an organization of Greek women interested in social and charitable activities." She also acted in local plays and gave dance performances. She and Philip had two sons and a daughter, Fifi, who died of influenza in 1931. (Right, courtesy Michael Anastas; below, courtesy Sophia Klide.)

Andrew Nickas was the brightest star in the Greek community. He joined the Cleveland chapter of AHEPA and was instrumental in bringing AHEPA to Stark County, serving as the first secretary of the Longfellow Chapter. At the 1925 national convention in Chicago, Nickas was elected supreme secretary. During his term, he crisscrossed the country promoting AHEPA, which witnessed its greatest period of growth and prosperity. (Courtesy Joanna Palacas.)

Even after stepping down from AHEPA national office at the end of 1927, Nickas remained a major figure. In 1929, he led more than 1,000 Ahepans on the second excursion to Greece. They were honored guests at a banquet hosted by Prime Minister Eleftherios Venizelos, and Nickas was grand marshal of a parade through downtown Athens. He and his companions are shown visiting the Erechtheion on the Acropolis. (Courtesy Joanna Palacas.)

Nickas was a compelling speaker and a strong leader. In Athens, he had the honor of delivering a speech from the spot where the great orator Demosthenes is said to have spoken. Upon his return to Canton from Washington, D.C., Nickas was elected president of the Longfellow Chapter, which in his absence had begun to show signs of disunity and soon ruptured. A new chapter was chartered in 1933, naming itself Andrew Nickas Chapter 289 in recognition of his services as the third supreme secretary. Nickas had a thriving law practice, but he also had political ambitions. He was the first local Greek candidate for office, running as a Republican for state representative in 1928, state senator in 1930 (below), and Ohio Supreme Court justice in 1934. (Above, courtesy Joanna Palacas; below, courtesy Rudy Turkal.)

 7

ANDREW NICKAS

ATTORNEY AT LAW

Candidate for

STATE SENATOR

21st DISTRICT (Stark & Carroll Counties)

He stands for Old Age Pension

Republican Primaries, August 12th, 1930

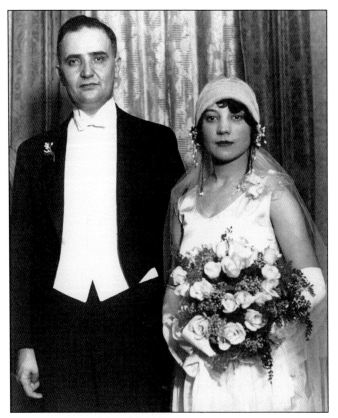

From the time he wed Maria Artopoulou in Washington, D.C., Andrew Nickas seemed to lead a charmed life. In Canton, the new Andrew Nickas Chapter 289 was thriving. His untimely death in 1935 devastated the community. The funeral in Canton was said to be the largest since the assassination of Pres. William McKinley in 1901. Nickas was buried at Arlington National Cemetery with Archbishop Athenagoras presiding. (Courtesy Joanna Palacas.)

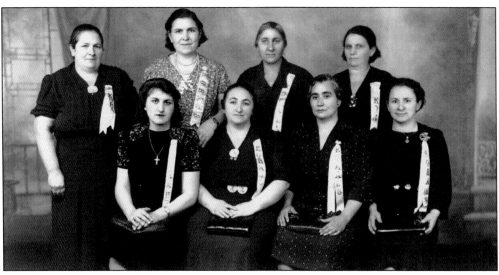

Initially AHEPA was indifferent or opposed to women's organizational efforts, and church groups absorbed their energies. Established in 1927, the Koraes Ladies Society of Holy Trinity Greek Orthodox Church is the oldest Greek women's organization in the area. Among the leaders was Helen Giavasis (seated second from the right), a native of Kalymnos. She and her husband George were married in 1928, settling in Canton in the early 1930s. (Courtesy Koraes Ladies Society.)

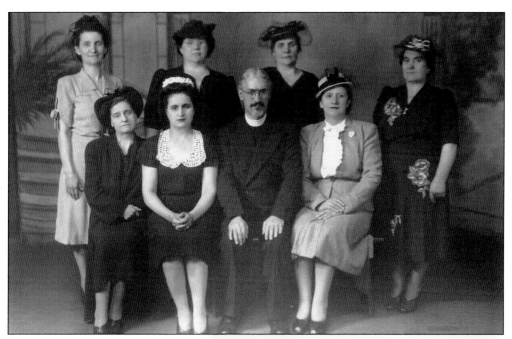

The Philoptochos Ladies Society was formally established in 1931 by Archbishop Athenagoras. At St. Haralambos Greek Orthodox Church, it developed out of an earlier organization called the Ladies Society of St. Panteleimon, which ministered to the needy in the parish. Philoptochos, meaning "friend of the poor," is a national philanthropic organization with a chapter in most parishes. Church organizations like this one are the most active and enduring organizations in the Stark County Greek community. Sam Kallison and Georgia Alex (shown on the right) were married at Holy Trinity in 1925, but Georgia later became active in Philoptochos at St. Haralambos. She was devoted to the organization, serving as president for about 15 years. She is shown in the photograph above, sitting second from the left. Her brother, Angel Alex, was a stalwart of the early AHEPA. (Courtesy Lula Contos.)

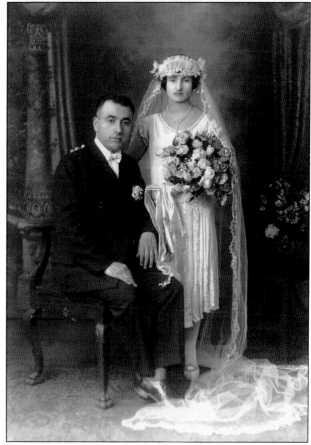

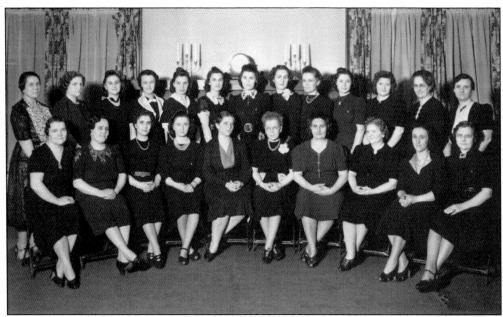

The first chapter of the Daughters of Penelope was established in San Francisco in 1929. It was officially adopted as the AHEPA ladies' auxiliary six years later. The establishment of Chloris Chapter 40 in Canton took place soon after. This was a bright spot at an otherwise somber time for the local AHEPA. Chloris was the ancient Greek goddess associated with spring, flowers, and new growth. The officers and board in 1940 are shown above. The president was Anthe Vutetakis, seated fifth from the left. Vutetakis also lent her talents to the stage, appearing in *The Heredity of Madame X*, a drama sponsored by the Daughters of Penelope at Timken High School on July 6, 1946. Both she and her husband James were from Crete. The family photograph below shows them with their four children. (Courtesy Irene Laggeris.)

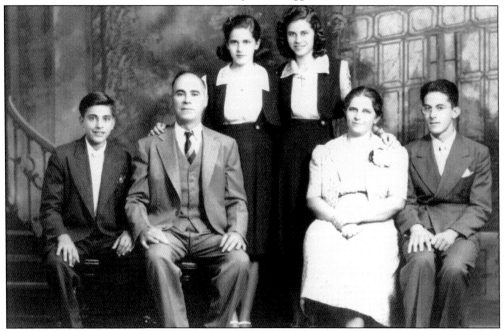

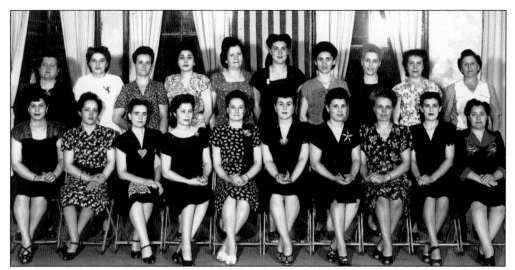

The Daughters of Penelope helped newcomers adjust to the local community. A number of Greek families moved from the Ohio River steel towns to find a better life in Stark County. Both Zoe Anesty (standing at the left) and Vassilia Sassos (standing fifth from the left) moved from Weirton, West Virginia. By 1948, they were members of the board of governors of Chloris Chapter 40. (Courtesy Elizabeth Tarzan.)

Philip Sassos (Simitacolos) was a World War I army veteran who returned to Smyrna, Asia Minor, married his sweetheart Vassilia, and brought her to the United States. During the Depression, Sassos worked as a cook in Pittsburgh, only seeing his family in Weirton on weekends. After the move to Canton, he worked at Richie's restaurant across from Stern and Mann's Department Store. (Courtesy Chris Anne Stavrianou.)

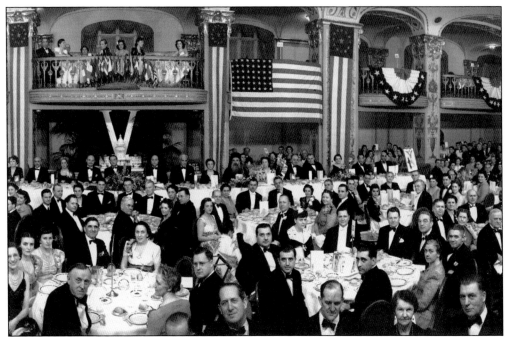

AHEPA held biennial banquets in Washington, D.C. In 1942, after the United States' entrance into World War II, the gala was centered on the war effort. In the background on the left, a large V for victory can be seen. As an official war bond issuing agent, AHEPA launched a nationwide bond drive. Within 21 months, AHEPA made headlines with sales exceeding $160 million. (Courtesy AHEPA Canton Chapter 59.)

The Nickas Chapter hosted the Buckeye District convention in 1942. The officers and board are pictured here. It was the first convention held in Canton since the Longfellow Chapter split apart in 1933. The war was providing a renewed sense of purpose, with the Canton chapters selling war bonds and also contributing $18,000 to the hospitals of Greece and $11,000 to Greek war relief. (Courtesy Helen Kostel.)

NEWS FROM OUR BOYS IN THE ARMED FORCES

Pvt. James L. Hontas, son of Mr. and Mrs. Louis Hontas of 1516 12th St. N. W., entered the Army in August, 1943, and received his basic training at Ft. Benning, Georgia. Pvt. Hontas is a graduate of Lehman High School in 1943 and at present is with the Signal Corps. at Camp Crowder, Missouri.

Pvt. Mino Geniatakis, son of Mr. and Mrs. Nick Geniatakis, a member of a signal corps somewhere in France. Inducted December 2, 1942 —he received training at Camp Beale, California, Camp Bowie, Texas, and Ft. Knox, Kentucky. A student of Timken Vocational High School—he was employed at the Wheeling & Lake Erie R. R. prior to induction. (His wife, the former Angeline Krearras and 2-year-old daughter reside in Canton). Three other brothers are also in service.

T/Sgt. John Geniatakis is somewhere in the Pacific with the Thirteenth Air Force. Inducted March 16, 1943—he received training at Camp Crowder, Missouri, Kessler Field, Mississippi, Lorrado, Texas, and California. A student of Timken Vocational High School—he was a former employee of the Republic Steel Corp. (He received a letter of commendation and the Air Medal for superior performance as a combat crew member during the recent South and Southwest Pacific campaigns).

PFC. Tony Geniatakis is somewhere in the Philippines with the Army Air Corps. Inducted March 16, 1943 (same day as his brother, John)—he received training at Camp Crowder, Missouri, Kessler Field, Mississippi, Lorrado, Texas, and Tampa, Florida. A student of McKinley High School—he was a former employee of the Hercules Motors Corp.

Cpl. George Geniatakis is stationed at Camp Pendleton, California, with the marine corps. Inducted March 4, 1942—he received training at Parris Island, South Carolina, and Quantico, Virginia. A student of Central High School—he was employed at Barberton, Ohio, prior to become a boxer and he's doing quite well for himself.)

Cpl. Nick Papacrist, son of Mrs. Soultana Papacrist of 208 Raynolds Pl. S. W., entered the Army Air Force October 30, 1942. Received his basic training at Hickman Field Florida. June 25, 1943, he received his wings at Camp Westover, Massachusetts. Cpl. Papacrist is a Radio

Storekeeper Third Class Sophia Pappas, daughter of Mr. and Mrs. Harry Pappas of 136 Fawcett Ct. N. W., was graduated recently from

PFC. Steve S. Klodakis, son of Mr. and Mrs. John Klodakis of 1712 Sherrick Rd. S. E., attended Timken Night School before being drafted.

Pvt. Gust Klodakis, also son of Mr. and Mrs. John Klodakis, was inducted in the Army on February 7, 1944. Before his induction, Pvt. Klodakis was employed at the Gogles & Son Poultry Market. Before going overseas, he was at Fort Riley, Kansas. Attended McKinley High School.

Cpl. Manuel Klodakis, son of Mr. and Mrs. John Klodakis, was inducted in the Army on March 15, 1943. He is in the Infantry. Before induction, Cpl. Klodakis was employed by the Gogles & Son Poultry Market. Was in England, Paris and now in

The Victoria Chapter of the Maids of Athena was established in May 1941. The organization would be officially recognized as the junior order of the Daughters of Penelope in 1950. From 1944 to 1945, the Victoria Chapter produced eight issues of the *VIMACAN*, a four-page newspaper sent to 600 Stark County Greek servicemen and servicewomen to boost morale with news of home and friends. The name stands for Victoria Maids of Canton. Financed by the Nickas Chapter, the staff of over 40 young women assembled the newspaper in the editors' homes and the Maids clubroom at the AHEPA hall on Tuscarawas Street East. It was the brainchild of Betty Georgiades (shown at the right), who served as editor in chief and supervised the staff. Georgiades had come to Canton with her family from their native Cyprus. (Above, courtesy Sophia Klide; right, courtesy Presbytera Bertha Shiepis.)

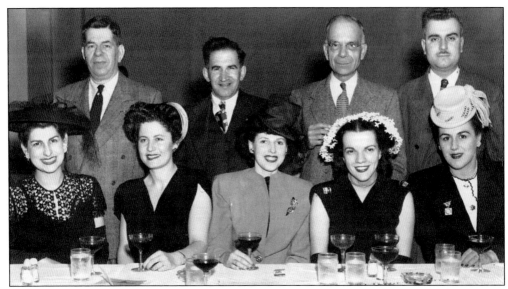

The war in the Pacific ended on August 15, 1945. A week later, Canton delegates to the AHEPA conference in Washington, D.C., celebrated at the Casino Royal Night Club. These mainstays of AHEPA, the Daughters of Penelope, and the Maids of Athena are, from left to right, Betty Georgiades, Emanuel Elite and wife Mary, George Tremoulis and wife Despina, Jack Biris and daughter Persephone, and Peter Kourmoulis and wife Sophia. (Courtesy Helen Kostel.)

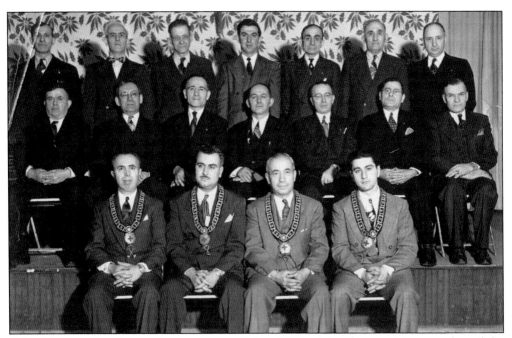

After 14 years, the Canton chapters reconciled in 1947, taking the prestigious number of the original chapter and the new name Canton Chapter 59. The Nickas Chapter provided most of the officers. Peter Kourmoulis (first row, second from the left) assumed the presidency. A grocer who introduced the supermarket to Canton and the first Greek candidate for mayor, Kourmoulis later became supreme governor of the order. (Courtesy Joanne Manos.)

The degree team was the elite unit of the Chloris Chapter and traveled widely throughout the region initiating new members into the Daughters of Penelope. The team was composed of veteran members who were familiar with the proper rites and procedures of the order and were eager to train others. Like their AHEPA counterparts, they took special pride in the regalia they wore at initiations. (Courtesy Helen Kostel.)

These young people, members of both Canton parishes, were among the early organizers of Greek Orthodox youth. One of the first groups formed was the Greek Orthodox Youth Club in 1948. The church established the Greek Orthodox Youth of America (GOYA) in 1951. The organization flourished as the first American-born generation came of age, offering stiff competition to the youth auxiliaries of AHEPA and GAPA. (Courtesy Irene Gianakis.)

On September 6, 1945, 50,000 spectators lined the streets of Canton to watch the victory parade celebrating the end of World War II. Above, Maids of Athena pose in front of the AHEPA float, which championed Greece as "the cradle of democracy." It won second prize. The talented designer was George Sideropoulos (shown at the left), who had survived many difficulties to become an engineer and architect. Sideropoulos was separated from his father for most of his youth, then became a refugee in Greece. After immigrating to the United States, he endured the humiliation of attending school for three years with children half his age as he learned English. He was the first member of Holy Trinity Greek Orthodox Church to attend college in the United States, studying engineering at Ohio University. (Above, courtesy Helen Kostel; left, courtesy Sideropoulos family.)

Sponsored by the AHEPA family and other Greek organizations, George Sideropoulos designed the float for the Canton sesquicentennial parade. Held on August 20, 1955, the parade, which was viewed by over 100,000 spectators, was the longest in Canton history, featuring 50 floats. The *Canton Repository* wrote, "Perhaps none was more impressive than the float of the Greek community and societies. A work of subdued but elegant splendor, it portrayed ancient temples of Doric, Ionic and Corinthian architecture and its figures represented the great philosophers and diety [sic] of the early ages of Greece." Groups including the Daughters of Penelope (below) marched in the parade. In 1805, when Stark County was created, Greece was not yet an independent nation. By 1955, some of the county's most important civic and business leaders were Greek Americans. (Photographs by Stanley Wojciechowski, courtesy Sophia Effantis.)

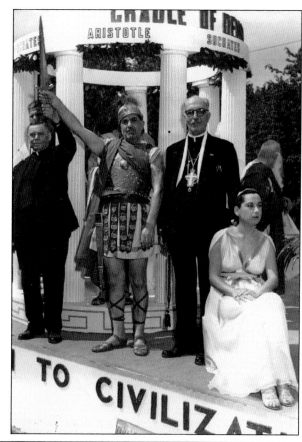

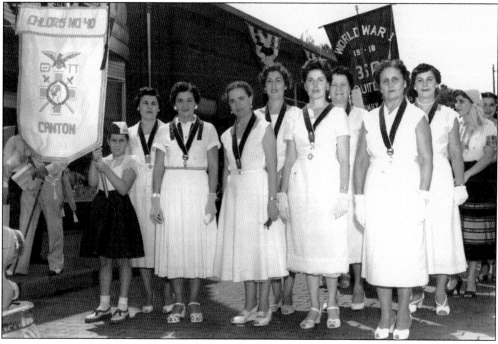

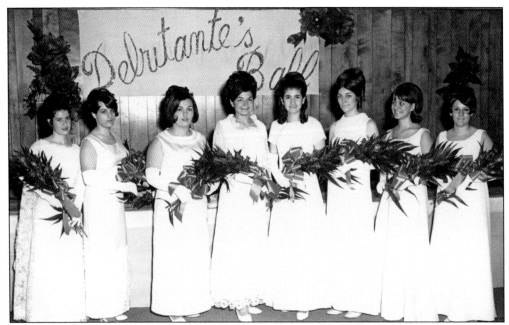

These photographs are from the first Daughters of Penelope debutante ball held in 1968. The eight debutantes, high school seniors of Greek descent, are, from left to right, Irene Peters, Elaine Klodakis, Mary Papadopulos, Cynthia Meskel, Anna Panterlis, Irene Christopher, Sophia Spilios, and Stacy Kiminas. Below are the members of the committee that organized the event. Pictured from left to right are (first row) Clara Pertginides, Dorothy Delianides, and Beth Shook; (second row) Sophie Demos, Joanne Nicholas, Flora Anderson, Sophia Klide, Jan Demos, and Mary Naves. These talented women planned so well that this formal dance has become the longest-continuing secular event in the Stark County Greek community. Over the last 40 years, more than 500 young women have taken part. The ball continues to be a major fund-raiser for scholarships. (Courtesy Daughters of Penelope Chloris Chapter 40.)

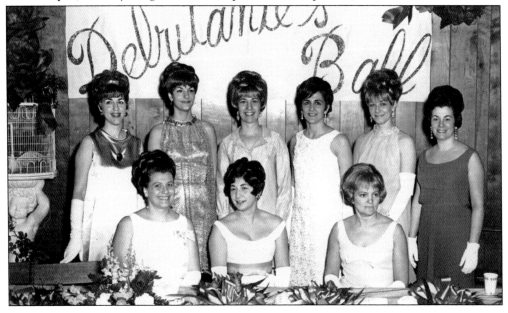

EPILOGUE

Over the past half century, the Greek communities showcased in this book have remained robust. For the churches, renovation and expansion have continued. In 1998, St. George Greek Orthodox Church built a $1 million cultural center. In 2003, Betty and Cyrus Yaghooti donated $500,000 to Holy Trinity Greek Orthodox Church for a state-of-the-art kitchen. In 2008, St. Haralambos Greek Orthodox Church received a $2 million gift from Alex D. Krassas to build an event center. Greek organizations still provide a meeting place for people from different parishes and religious affiliations. In 2003, the Canton chapters of AHEPA and the Daughters of Penelope, together with the United States Department of Housing and Urban Development, opened a beautiful apartment complex for senior citizens on Market Avenue North between the two Canton churches.

On the national stage, St. George parishioner Zack Space was reelected to Congress in 2008 for a second term representing Ohio's 18th Congressional District, which includes Tuscarawas County. Space's grandfather Zacharia immigrated from Ikaria in 1913. He and his wife Despina would settle in Dover. Also, in 2008, former Holy Trinity head altar boy seven-feet-tall Kosta Koufos was selected by the Utah Jazz in the first round of the NBA draft. His grandfather immigrated in 1916 from Smyrna, Asia Minor. He owned the Dew Drop Inn on Carnahan Avenue in Canton for a quarter century.

In 2004, the authors were guest curators of a large-scale exhibition of the history of the local Greek community at the William McKinley Presidential Library and Museum. It was a first for the Greek community, or for any ethnic community in this diverse county. The exhibition helped lay the groundwork for a part of this book.

There have been great changes in Stark County since the photographs in this volume were taken. The industrial base that attracted so many immigrants a century ago has largely disappeared. With the loss of jobs, there has also been a loss of population, and there are few new Greek immigrants. It remains to be seen how courage, hard work, and imagination can help meet these challenges and shape the future of the Greeks of Stark County.

DISCOVER THOUSANDS OF LOCAL HISTORY BOOKS
FEATURING MILLIONS OF VINTAGE IMAGES

Arcadia Publishing, the leading local history publisher in the United States, is committed to making history accessible and meaningful through publishing books that celebrate and preserve the heritage of America's people and places.

Find more books like this at
www.arcadiapublishing.com

Search for your hometown history, your old stomping grounds, and even your favorite sports team.